Stones of the Sur

Selected and Introduced by

JAMES KARMAN

Stones of the Sur

Poetry by Robinson Jeffers • Photographs by Morley Baer

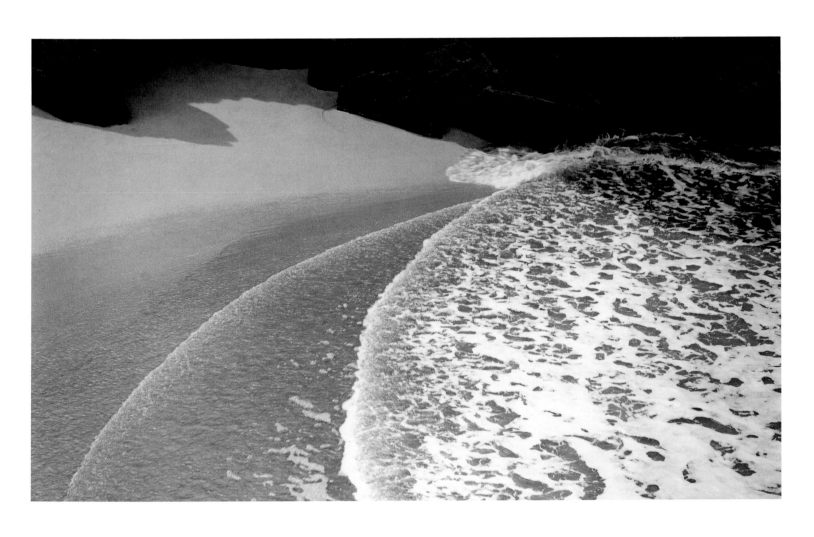

STANFORD UNIVERSITY PRESS, STANFORD, CALIFORNIA

Stanford University Press
Stanford, California
© 2001 by the Board of Trustees of the
Leland Stanford Junior University

Printed in the United States of America
on acid-free, archival-quality paper.

Published with the assistance of
The Judith Rothschild Foundation
and the Trustees of The Robinson Jeffers
Tor House Foundation.

CIP data and copyright information
appear at the end of the book.

Contents

Acknowledgments

This book would never have appeared without the help of many people, first among whom is Frances Baer. I am very grateful for the advice and assistance she provided from the moment *Stones of the Sur* first set forth as an idea until it reached safe harbor as reality.

I would also like to thank Norris Pope, the editorial director of Stanford University Press, whose knowing hand held firm to the rudder throughout the journey.

The introduction to *Stones of the Sur* was completed during the summer preceding a fellowship year funded by the National Endowment for the Humanities. I wish to thank NEH for its generous support of my research on Jeffers, extended with special kindness through Margot Backas, Joseph Neville, and Kathy Toavs.

I also wish to thank The Book Club of California for providing a Book Club Grant in support of this project. Additional financial support came from John Hicks and J. S. Holliday, who championed *Stones of the Sur* right from the start, and Robert Buck—all trustees of the Robinson Jeffers Tor House Foundation. A generous grant from The Judith Rothschild Foundation helped with photograph reproduction costs.

I am also grateful to the families of Donnan Jeffers and Garth Jeffers—particularly, Lindsay, Maeve, Brenda, and the late Lee Jeffers—for their steadfast encouragement and enthusiasm. Others who contributed to the publication of this book and deserve my heartfelt thanks include Helen Tartar, Matt Stevens, Lorraine Weston, and Eleanor Mennick, all of Stanford University Press; Robert Zaller, past president of the Robinson Jeffers Association; Tim Hunt, editor of *The Collected Poetry of Robinson Jeffers*; Patrick Jablonski, Baer's darkroom assistant and adviser to the Morley Baer and Frances M. Baer Trust; Rita Bottoms, head of special collections and curator of the Morley Baer Archives at the University of California, Santa Cruz; John Varady, Rob Kafka, Allen Mears,

Albert Gelpi, Joel Leivick, Jeffrey Becom, Sally Aberg, Roberta Karman, Karen Gartelos, and Tony Karman.

Finally, I wish to thank my wife, Paula, for her help during every phase of this project. As first and last reader, her advice proved indispensable. She remains, as always, my lodestone and rune stone—the sure foundation of all that is.

 Stones of the Sur

I

Here, at least, I shall haunt, and as the time-streams
bend and swirl about the Rock, I shall see again all
the times that I have loved, and know certainly all
that now I guess at.

When Morley Baer found this passage in Mary Austin's *The Land of Journeys'
Ending* many years ago, he copied it onto an envelope and, without explana-
tion, placed it on his wife's desk. Frances, his wife, read the passage and, with-
out question or comment, tucked it in her journal. In a moonlit marriage—
where tidal forces are at work and an air of mystery prevails—exchanges such
as this, silent and inscrutable, are common.

The passage reappeared at its appointed hour years later, in the spring of
1995. Frances had just learned that Morley was afflicted with a terminal illness
and had only a short time to live. Walking about their home in a stupor, numb
from the icy lightning in the air, she absently picked up her journal and the
long-forgotten envelope fell to the floor.

The words provided some comfort. They spoke of life after death, positing a
spirit that endures in a consecrated place, unmoved by the flow of time, know-
ing all there is to know. Austin, who once lived just north of the Big Sur in
Carmel, California, was referring to Inscription Rock in the El Morro moun-
tains of New Mexico. She wished she could be buried there and remain part of
the land forever, sharing its beauty: "You, of a hundred years from now, if when
you visit the Rock, you see the cupped silken wings of the argemone burst and
float apart when there is no wind; or if, when all around is still, a sudden stir in
the short-leaved pines, or fresh eagle feathers blown upon the shrine, that will
be I, making known in such fashion as I may the land's undying quality."

This, Frances knew, was Morley's desire, too, but the land he wished to be
part of forever was the Big Sur coast of California, and the Rock he held sacred
was a large boulder near the mouth of Garrapata Creek. The "Black Rock," as he

called it, served as a silent sentinel. To be on watch with it, to witness the sea-coast in all its days and nights, in storm and quietude, would be the perfect way for him to spend eternity.

So, after Morley died in November 1995, Frances brought his ashes to this hallowed place. During a brief memorial with family and friends, Frances read the fateful passage from *The Land of Journeys' Ending*. Then Joshua, their son, dropped handfuls of bone dust into Garrapata Creek. Frances followed with rose petals. Flowers and ash swirled in the current, flowed past the Black Rock, and played out upon the surf-lapped sand. The last handful of ash, unfurled closer to the ocean's edge, was caught in midair by a brash wave that suddenly appeared and fell back in thunder to the sea.

II

Morley Baer was born in Toledo, Ohio, in 1916 and grew up in the Midwest. As a boy, he listened to his grandfather's vivid descriptions of the golden hills of California and dreamed of living there. Interest in California increased when he read the poetry of Robinson Jeffers at the University of Michigan in Ann Arbor, where he earned a B.A. and M.A. in Literature.

After completing his studies, Baer accepted a position in the advertising office of a department store in Chicago. The banality of writing newspaper ads soon provoked him to quit, however, and without thinking much about it, he took a job in 1938 with a firm that specialized in commercial photography. Baer's tasks were menial at first, but he slowly assumed more responsibility. Much of the firm's business involved architecture and, after learning how to handle a camera, Baer was trusted with the fieldwork. Before long, he began developing and printing photographs as well.

During this apprenticeship, Baer thought of photography in purely technical terms. The mechanical aspects of the camera—including all the variables of film, focus, light, shutter speed, and aperture setting—fascinated him, as did the chemical procedures of the darkroom. His interest in photography changed and deepened in 1939 when he attended an exhibit of Weston's work and read one of his essays. The whole artistic side of photography suddenly opened up for him, and he began to see how the camera could be used for self-expression.

Weston had long been a proponent of "straight" photography, a style that eschewed tonalist and pictorialist effects in favor of clear, unmanipulated images. Early in the decade he was affiliated with "Group f.64," an association of like-minded photographers who chose for their name the shutter opening that pro-

vides the sharpest focus with the greatest depth of field. Ansel Adams and Imogen Cunningham joined Weston as original members of the group, along with John Paul Edwards, Sonya Noskowiak, Henry Swift, and Willard Van Dyke. Though each artist developed a distinctive style, they shared a commitment to visual purity and the pursuit of objective truth. An entry in *The Daybooks of Edward Weston*, dated March 15, 1930, expresses some of their convictions.

I want the stark beauty that a lens can so exactly render, presented without interference of "artistic effect." Now all reactions on every plane must come directly from the original seeing of the thing, no secondhand emotion from exquisite paper surfaces or color: only rhythm, form and perfect detail to consider. Honesty unembellished—first conceptions coming straight through unadulterated—no suggestion, no allegiance to any other medium.

Of all the members of the group, Weston was perhaps the most committed to the pursuit of "stark beauty." His concern for the simple "suchness" of an object—shell, pepper, nude—enabled him to isolate whatever fell before his gaze, to free it from the constraints of time, space, and culture, and present it for contemplation *sub specie aeternitatis*.

The astringency of Weston's aesthetic convictions proved influential in the 1930s, as a wave in modern art moved further in the direction of abstraction, but other options were open. Alfred Stieglitz, an early and leading proponent of photography as fine art, explored the expressive possibilities of the camera with his "Equivalents"—simple studies of natural phenomena, such as clouds, which captured his inner emotions. Man Ray and others experimented fruitfully with surrealist interventions, creating hybrid images such as the photomontage in an effort to undercut conventional expectations concerning reality and truth. In the middle of the decade, a legion of photographers—sent forth by President Roosevelt and the Farm Security Administration—documented the plight of the underprivileged and the oppressed. In the hands of Dorothea Lange (who herself was an associate member of Group f.64) and other gifted artists, cameras proved to be highly effective instruments of political persuasion. Margaret Bourke-White used her formidable skills to provide eyewitness accounts of world events and the people who shaped them. Through her involvement in *Life* magazine, which first appeared in 1936, she helped create and feed America's growing appetite for visual images. The photographic essay, popularized by her and others in the pages of *Life*, captivated subscribers with its innate rhetorical power and immediate emotional appeal. Edward Steichen also reached a mass audience, bringing the principles of art photography to celebrity portraiture and advertising. His work appeared in *Vanity Fair*, *Vogue*, and other style-setting magazines.

But it was Weston who captured Baer's imagination and marked the trail that he should follow. The revelation was so swift and thorough that Baer felt an urgent need to meet the master. He wanted to see Weston at work and inquire about an apprenticeship. An assignment in Colorado brought Baer half the distance from Chicago to the West Coast, close enough in his mind to justify a journey to Carmel-by-the-Sea. He traveled the remaining miles and, upon arrival, looked for Weston. Unfortunately, Weston had left Carmel just days before, but the dark and fragrant pines were there, as was the vast, eternal ocean, and the beautiful crescent bay, where endless rows of waves, with white manes flowing and forelegs curling, cantered like wild horses onto the sand.

When Baer returned to Chicago, with an experience of California that surpassed even his grandfather's extravagant descriptions, he knew he would return. However, the outbreak of World War II soon interrupted his plans. In 1941, following the attack on Pearl Harbor, he enlisted in the Navy, where he put his aptitude with the camera to immediate use. As an ensign and then a lieutenant, Baer documented naval operations in both the Atlantic and Pacific. He sailed on various vessels, including the carrier Lexington, to northern Africa, southern France, Brazil, and the Caribbean. Eventually, he was assigned to Edward Steichen's Naval Combat unit. Steichen had served as the director of aerial photography for the Allied forces in World War I. At sixty-two, he selflessly volunteered for service once again. His leadership inspired Navy photographers to do their very best work. Baer, taking dozens of pictures a day and thousands in all, in constantly changing conditions, quickly perfected his skills. By the time he was released from the Navy in 1946, he was a complete and confident professional.

For his last port of call, Baer sailed into San Francisco. And so, at war's end, he found himself right where he wanted to be—in California. Before long, he met and married Frances Manney, who lived in Palo Alto. A photographic assignment from the Navy brought the couple to Monterey.

Soon thereafter, Baer set up a darkroom in Carmel. Business was predictably slow at first, but he gradually obtained commissions from *Sunset* magazine and other publications. Eventually, as he and Frances made a life for themselves among the artists and intellectuals of Carmel, they were introduced to Edward Weston and Ansel Adams, who, by then, were among the most famous and influential photographers in America. While it was too late for Baer to work with either one as an apprentice, the two befriended him, and Baer frequently turned to them for advice. On one such occasion, in 1948, Baer asked about photographing Robinson Jeffers. The poet's adaptation of *Medea*, starring Judith Anderson, had just triumphed on Broadway, and *Theatre Arts* magazine

was planning an article about him. Baer, commissioned to supply a portrait, was anxious about meeting Jeffers and capturing his image accurately. "Don't worry about it," said Weston, who had photographed Jeffers many times. "Don't be frightened by him. You'll find that he makes the photograph much more than you will." Weston was right. Baer knocked on the door, greeted Jeffers, and asked him to come out and stand by a wall beside the house. "He stood there for a moment," said Baer in recollections presented at a Robinson Jeffers Tor House Foundation conference in 1992, "he hadn't said two words. I don't think I directed him at all. All of sudden, the nose—the profile—went up against the rocks. I saw one of the most beautiful outlines of a human head I've ever seen. It had dignity, a force, the appreciation of this world, all encased in sinewy, gaunt lines that I can't today forget. It was a great moment for me, and yet very, very little was said."

The combined effect of meeting Jeffers and rereading his poetry was similar to the illumination that occurred when Baer first discovered Weston. A profound philosophy of life, a complete aesthetic vision, suddenly made itself known to Baer at the deepest levels of his being—and he never saw the world the same way again. When he took his camera to the coast and started to study the landscape himself, a "seepage," as he called it, was there. "Jeffers helped me see and sense the coast of California as a place of great tensions, great natural tensions that are part of life and not to be subdued and eradicated." Capturing this wild beauty on film, as Jeffers had captured it with words, became his true life's goal.

In this, he was not alone. Weston had been profoundly influenced by the poet —as a friend, as a fellow artist, and as a subject. Entries in his *Daybooks*, such as this one from May 29, 1929, record his impressions after a portrait session.

I made three dozen negatives of Jeffers,—used all my magazines: and developed the moment I got home. It was another grey day, but I now realize, knowing him better, that Jeffers is more himself on grey days. He belongs to stormy skies and heavy seas. Without knowing his work one would feel in his presence, greatness. His build is heroic—nor do I mean huge in bulk—more the way he is put together. His profile is like the eagle he writes of. His bearing is aloof—yet not disdainfully so—rather with a constrained, almost awkward friendliness. I did not find him silent—rather a man of few words. Jeffers' eyes are notable: blue, shifting—but in no sense furtive— as though they would keep their secrets,—penetrating all seeing eyes. Despite his writing I cannot feel him misanthropic: his is the bitterness of despair over humanity he really loves.

Jeffers inspired Weston, not so much for the particulars of his philosophy, but for the strength of his personality, his love of natural beauty, and his uncom-

promising devotion to the life of art. A portrait of Jeffers, one of Weston's best, appeared on the cover of *Time* in April 1932.

Jeffers inspired Adams, too, as entries in *Ansel Adams: Letters and Images 1916–1984* reveal. Writing to Albert Bender in 1927, Adams says, "I have been reading a good deal of Jeffers whenever I have the chance, and he grows on me constantly. The power and vitality of his verse blends so perfectly with the rugged mountains. I think he is *great*." About ten years later, he had Jeffers in mind when he decided to renounce "any and all photographic work of a purely 'commercial' nature" and "concentrate on honest things." Writing to his friend Alfred Stieglitz in 1936, he quotes four lines from *Return* and declares his intention to simplify his life and renew contact with the natural world. Jeffers' poems, he adds, "sound more music and pile more mountains in the spirit than almost anything I know of." Writing to Stieglitz again in 1945, Adams reaffirms his commitment to pure photography and to the poet who inspired him. "I am going to do my best to call attention to the simplicities of environment and method; to 'the enormous beauty of the world,' as Jeffers writes. Pray for me."

In fact, then, there was a triple seepage at work when Baer turned his camera to the landscape around him—from Jeffers himself through his poetry and from Jeffers through Weston and Adams.

This was no doubt what Steichen noticed when, early in the 1950s, Baer showed him some of his photographs of the California coast. Baer, visiting New York with Frances, arranged to meet Steichen at the Museum of Modern Art, where his former commanding officer served as the director of the newly formed photography department. Steichen studied Baer's photographs for a moment, praised their technical skill, then questioned their similarity to the landscapes of Weston and Adams. "Why keep digging in the same hole in the ground?" he asked. Steichen, the quintessential New York photographer, was more concerned with people than nature. Indeed, when Baer visited him, he was working on *The Family of Man*, a collection of photographs that captured the everyday lives of men, women, and children around the world. When the exhibit opened in 1955, the engaging images, supplied by several dozen photographers, proved to be immensely popular. For Steichen, living in bustling New York after the war, with the United Nations buildings under construction and a new spirit of industry and cooperation in the air, Baer's photographs of stark cliffs and empty beaches were pointless. Without people, what value could they have?

No answer was forthcoming at the time. Not just the continent itself but an artistic and philosophical chasm just as wide separated Baer from Steichen. A few years later, though, Baer was proud to contribute photographs to *Not Man Apart*, a publication sponsored by the Sierra Club and guided by Adams. It

combined lines from the poetry of Jeffers with photographs of the Big Sur coast by Adams, Weston, Baer, Wynn Bullock, Eliot Porter, and others. In some ways, as the title itself suggests, the stoic Inhumanism of *Not Man Apart* served as a rejoinder to the narcissistic sentimentalism of *The Family of Man*. With Jeffers' words providing something of a credo, the landscape photographers of California responded forcefully to the urbane photographers of New York.

As Baer continued photographing landscapes through the 1950s, he also established himself as a leading architectural photographer, doing portfolio work for architects and interior designers while freelancing for housing design magazines. Even this work may have been influenced by Jeffers, for very few of Baer's photographs included humans as subjects. He was interested in how people lived, how they shaped the space around them, but he was not interested in people themselves. In 1965, the American Institute of Architects awarded Baer a Gold Medal for Photography.

A long sojourn in Germany and Spain followed by the purchase of property on the coast south of Carmel enabled Baer to preserve his independence and to pursue his own vision of truth and beauty. He did so in an extraordinary home he built on a dramatic bluff overlooking the Pacific. Designed by William Wurster and constructed of stone, it looked north and south along the coast from a vantage point just above Garrapata Creek. Simple and austere, yet comfortable, the studio/home brought Baer into immediate contact with sea and sand and wind. The path from the front door led down to Garrapata Beach where, on daily walks with camera in hand, he befriended the Black Rock.

Baer lived in the home for about fifteen years, during which time he exhibited and published widely. *Here Today*, a study of historic buildings in and around San Francisco, appeared in 1968; *Adobes in the Sun*, which focused on the early structures of Monterey, was published in 1973; *Bay Area Houses* was published by Oxford University Press in 1976; *Painted Ladies*, a study of San Francisco's Victorian heritage, came out in 1978; and *Room and Time Enough*, a tribute to Mary Austin, appeared in 1980. Also in 1980, Baer was awarded a Prix de Rome by the American Academy in Rome, where he spent a year photographing fountains and historic buildings.

Though Baer valued solitude more than companionship, he enjoyed working with students and devoted time throughout his life to teaching—at the San Francisco Art Institute; at the University of California, Berkeley, Santa Barbara, and Santa Cruz; in Friends of Photography workshops; in his own Master Photographers Invitational workshops; and in workshops with Ansel Adams at Yosemite and in Carmel. In an unpublished introduction composed for one such event, Adams describes Baer as "a master in his field" and "a splendid example of the

well-rounded artist and professional." Baer's work, he says, "has the aura of excellence and his craft is above reproach. I know of no one with a broader knowledge of large-format photography in both the expressive and applied domains."

After 1980, while continuing to teach and photograph architecture, Baer devoted more and more attention to landscape studies. *The Wilder Shore*, published by the Sierra Club in 1984, includes eighty of Baer's photographs of California along with a meditative text by David Rains Wallace and a foreword by Wallace Stegner. In a section titled "Photographer's Notes," Baer explains the thoughts and feelings that inspired his work. He describes the rapture he felt one day as he watched the surf crash against the rocky shore and realized that "the ultimate argument between land and sea" was occurring right before his eyes. "Nowhere else," he says, referring to the coast of California, "is the conflict more impressive. Nowhere else are the natural fundaments at the edge of a continent arrayed in such magnificent opposition." The photographs published in *The Wilder Shore*, he adds, offer "only a hint of the appreciation I feel for the sublime experience of living in a place I love."

The love Baer felt for California and for nature is evident in the images selected for *Light Years: The Photographs of Morley Baer*, a retrospective published by Photography West Graphics in 1988. In a brief preface to the book, Baer restates his conviction that heart and mind play an all-important role in camera work. "Sensitivity and perception, a synthesis of emotional excitement and intensity of purpose combine with the entire accumulation of living to turn reality into image." Photography, he says, "becomes the means through which one makes a statement about the love of place. Finally, the place and the statement become sacramental. They make life itself worthwhile."

Light Years was Baer's last book. He continued to work in the early 1990s, but his eyesight began to fail and illness gradually overwhelmed him. At the time of his death he was thinking about one last project—*Stones of the Sur*.

When Baer invited me to serve as his collaborator, he expressed a wish to create a book wherein his photographs and Jeffers' poetry would be presented side by side. Though *Not Man Apart* served as a model, Baer had something more focused in mind. He wanted to offer a visual and literary meditation on the life-experience of stone. At first glance, he knew, the images might prove disaffecting. Without a human element to capture attention, picture after picture of rocks—and poems about them—might alienate some readers. If one looks closely, however, as he had done for decades, if one thinks deeply, as Jeffers demands, then, Baer believed, rocks can serve as teachers, revealing much about themselves—their own unique personalities—and about the meaning and the mystery of the world.

III

In the ancient Greek account of creation popularized by Hesiod in his *Theogony* (c. 700 B.C.E.), four divinities appear at the beginning of time. First comes Chaos, a being that encompasses pure potentiality. Anything is possible with Chaos, but nothing is actual. Then Gaia materializes. She is "Mother Earth," physical reality, the stuff and substance of all that is. Within or under Gaia, darkness gathers—Tartaros, deep and dreadful beyond imagining. Finally, shining Eros breaks forth, irradiating the universe with the energy of intense desire. Gaia, quickened by Eros' primal power, creates a husband for herself and begins birthing the world as we know it, in all its variety and abundance.

If one adds this myth to the dictum that "phylogeny recapitulates ontogeny" (an individual's growth retraces the evolutionary development of its species), one obtains a workable symbolic model of Robinson Jeffers' maturation as an artist. First, there was a long period of Chaos—all the years of childhood and youth during which Jeffers lived and traveled in Europe; learned Greek, Latin, French, German, and King James' English; studied literature, philosophy, medicine, forestry, and law; fell recklessly in love; settled in Carmel with his wife, Una; had twin sons, Garth and Donnan; and struggled, as a poet, to find something worthwhile to say. Then, within this Chaos, Gaia appeared—in the woods and riverbanks of Jeffers' native Pennsylvania; the awesome lakes and mountains of Switzerland; the garden paradise of southern California; the forests of the Pacific Northwest; and, above all, in the wild Big Sur and Monterey Peninsula. All along, darkness gathered, yawning Tartaros, a vast underworld where Death and Night and Dreams all lived: big enough to contain all the ruins of Western Civilization, brought down by World War I; deep enough for more personal losses, like Jeffers' titanic father and his first-born child, a daughter who only lived a day; black enough for Jeffers' fiercely independent spirit, a "bird with dark plumes," as he called it, to sit and brood. And finally—or simultaneously, for strict chronology is meaningless here—Eros rose like the morning sun, opening Jeffers' eyes to the wonder of the world and filling his heart with aching passion.

Jeffers became a poet, in the fullest sense of the word, in the summer of 1919. He and Una were living in Carmel. Although the bucolic existence was deeply satisfying—with twin sons, a cabin in the woods, and a small but vibrant community of artists and intellectuals around them—Jeffers was distressed by his inability to find his own voice as a writer and by the uncertainty he had experienced over whether he should enlist for service in the Great War. As he struggled to find his way, he devoted himself to strenuous physical labor. He walked each day to a barren bluff just south of the village to help build Tor

House, his new home, an English-style cottage, planned by Una and made of stone. In the midst of that labor, the ancient granite boulders, which he hauled from the shore and helped cement in place, opened up for him, revealing secrets about themselves, his own personality, and the cosmos as a whole. Una describes the epiphany in a letter written to Lawrence Clark Powell in 1934.

The conflict of motives on the subject of going to war or not was probably one of several factors that, about this time, made the world and his own mind much more real and intense to him. Another factor was the building of Tor House. As he helped the masons shift and place the wind and wave-worn granite I think he realized some kinship with it and became aware of strengths in himself unknown before. Thus at the age of thirty-one there came to him a kind of awakening such as adolescents and religious converts are said to experience.

The awakening, like a key, turned the tumblers of Jeffers' psyche and, suddenly, all the doors of perception and creativity were unlocked. The first major poem to come forth was the stunning *Tamar*, a long narrative about a young woman, goddess-like, who is beset by forces from the underworld and consumed by destructive desire. *Tamar* was followed by *The Tower Beyond Tragedy*, *Roan Stallion*, a host of short lyrics, and such epics as *The Women at Point Sur*, *Cawdor*, and *Thurso's Landing*. In a singular career that lasted over forty years, Jeffers published fifteen major books of verse, all inspired by the same prophetic vision. While always controversial and perhaps never fully understood, Jeffers became "the great elder" of west coast writing, as poet laureate Robert Hass has called him, captivating general readers and influencing artists and thinkers in a wide variety of fields. And it all began, as Una says, when Jeffers was building Tor House, handling stone.

Tor House, now a national historic landmark, came forth from the same revelation, the same well-spring of wisdom, that produced Jeffers' poems. Enclosed by a stone wall and beautiful garden, guarded by Hawk Tower, it looks out upon the sea. There is something timeless and monumental about it, something perfectly natural and serene. As Stewart Brand says in *How Buildings Learn*, "Tor House is a poem-like masterpiece. It may express more direct intelligence per square inch than any other house in America."

Among its many charms are the countless stones from around the world that Jeffers cemented into the walls. While most were found by Robinson and Una or by their sons, many were given to them by friends. Treasures include pebbles from the beach below "King Arthur's Castle" at Tintagel, obsidian from Glass Mountain in California, black lava from Mt. Kilawea, white lava from Mt. Vesuvius, green marble from Connemara, white marble from the Greek island of

Delos, cinnabar from Almaden, meteorite from Arizona, pink stone from the banks of the Oka River in Russia, fossils from Iowa, fieldstones from Michigan, and stones from historically significant sites throughout the British Isles, including all the round towers visited by the Jefferses in Ireland. In addition to these "undressed" stones, countless others were worked by human hands, such as a ceramic shard from the Temple of Heaven in Beijing, a fragment of a gravestone carved with a cross from county Donegal in Ireland, a millstone from New Mexico, an arrowhead from Michigan, a Babylonian tile inscribed with a prayer to Ishtar from the temple at Erich, a carved stone head of a "heavenly maiden" from the temple of Prah-Khan in Cambodia, Pre-Columbian terracotta heads from Central America, part of an obsidian sacrificial dagger, a carved stone Aztec mask, a carved human torso from a temple in southwest India, tesserae from the Baths of Caracalla in Rome, a fragment of a mosaic from the Roman city of Timgad in northern Africa, a plaque containing a portion of wall painting from Pompeii, a fragment of white stone from the Great Pyramid of Cheops, a piece of the Great Wall of China, shards of tile from Kenilworth Castle in England, stone from the manor house of George Moore, stone from Yeats' tower in Ballylee, a red stone from Lord Byron's home, stones from the ruins of Melrose Abbey and from Dryburgh Abbey in Scotland, tiles from the San Antonio Mission near Jolon, and a lintel from the San Carlos Borromeo Mission in Carmel.

As a realist, Jeffers knew that the value of these stones rested in their historic associations or simply in their distinction as geologic specimens. He thoroughly understood and embraced the scientific world view of his time. Indeed, the physicist Freeman Dyson, writing in *The New York Review of Books* (May 25, 1995), compares Jeffers to Einstein and says, "He expressed better than any other poet the scientist's vision." On the other hand, Jeffers was also a "pure example of *poetas religiosus*," as William Everson describes him in *The Excesses of God: Robinson Jeffers as a Religious Figure*, and thus, as a metaphysician and a mystic—like Dante, Milton, Blake, or Whitman—he valued stones for their symbolic significance and for their sacredness and power.

Jeffers' sensibilities, in this regard, were only a more concentrated form of feelings shared around the world and throughout time. Indeed, mountains, rocks, and stones have played such a central role in the cultural and spiritual life of humankind that it would be difficult to find anyone who has not felt some degree of reverence for them. Consider the role of Sinai or Olympus in human history. Such mountains and others like them—Shasta, Machu Picchu, Croagh Patrick, Mont Blanc, Athos, Parnassus, Ararat, Annapurna, Nanda Devi, Fuji— have always inspired the deepest awe. Stories about the deities that reside or

reveal themselves upon them provide the basis for much of the world's mythology. All the menhirs, cromlechs, dolmens, and cairns of the ancient world give further evidence of stone's intrinsic holiness, as places such as Stonehenge still attest. Like the omphalos at Delphi that centered ancient Greeks or Jacob's stone pillow that oriented Jews, the Black Stone of the Ka'bah in Mecca anchors Muslims even now. Ithyphallic herms, Shiva's linga, Scandinavian rune stones, the married stones in the Bay of Ise, rock gardens in Zen Buddhist temples, Chinese scholars' rocks, precious gems: these are only a few examples of the countless ways stones have elicited veneration.

Like any archetype, stone is multivalent. Though it presents itself as hard, cold, and unfeeling—and thus appears to be dead—there is a sense of latency or potentiality about it, as if it once was, or in the future could be, living. Stories about Niobe, Lot's wife, or the victims of Medusa's stare, for instance, reflect the age-old conviction that stones, mountains, or natural formations can hold the petrified remains of vital spirits. In the same way, what appears to be merely finely ground stone in the form of dust or clay, can, when molded by such deities as Yahweh or Prometheus, become prototypically human. Or, in another example, the simple stones tossed over their shoulders by Deucalion and Pyrrha in the Greek version of the flood story can, as the "bones" of Mother Earth, instantly turn into people. Stone is Janus-like; it points both ways toward life and death; it unites time and eternity. It is the numinous *prima materia* that marks graves and bestows fertility.

Massive stones on Carmel Point, the site of Tor House, were sacred to Robinson and Una before they even bought the property. The "Standing Stones," as they called them, were a favorite destination on daily walks along the coast. The site was "active" for them, they felt a presence there, as Jeffers later declared when he placed lines from Psalm 68 on the turret of Hawk Tower: "Why leap ye, ye high hills? This is the hill which God desireth to dwell in." The largest of the Standing Stones, which became the cornerstone of Tor House, was named Thuban, after the star in the constellation Drago that serves, in cyclic turn, as one of Earth's polestars. Another large boulder, north and down the hill a way, was called the Altar Stone. According to a descendant of one of the tribes that had lived in the area, native women revered the stone for the help and protection it provided during pregnancy. As a "birthing" stone, it gave them strength when they pushed against it with their backs during delivery. The site of Tor House itself was a midden; remains from seasonal feasts covered the hill. The bedrock—at the very spot Robinson and Una eventually built their dining room and excavated for a fireplace—was charred from countless ancient fires.

Evidence of human habitation along the central California coast goes back

about eight thousand years—roughly to the period after the last Ice Age, when the ocean reached its present level and the current coastline came into view. During all that time, as small tribes of people settled the Big Sur and then moved on—perhaps with centuries between them—the site of Tor House probably did not change. As Egypt erected the pyramids, and the great civilizations of Greece and Rome took shape, and human history, with all its blood and music, pursued its staggered course, Thuban and the Altar Stone sat perfectly still, oblivious and serene.

Overhead, at about the time of Moses, Thuban the star lost his place as lord of the night sky. Virtually all of recorded human history has occurred with Polaris at the pole. But Polaris' reign will also pass, and other stars will occupy the central place—until, after about twenty-five thousand years, in what is called the "precession of the equinoxes," Thuban will return and rule again. When this happens, it will be nothing new to Thuban the cornerstone; he has seen the whole wheel turn countless times before.

The coarse-grained, crystal-flecked granite on Robinson and Una's hill was formed as the result of events and processes that go back 130 million years and more. At that time, a huge mass of Earth's crust, called the Farallon plate, collided head-on with the North American continent. The leading edge of the plate melted as it was pushed down under the continent into the fiery magma below. Then, as it cooled over millions of years, the material slowly solidified and rose back to the surface as granite. The last of the Farallon plate disappeared into the abyss about thirty million years ago, at which time the Pacific plate and the North American plate met and began to slide laterally past each other. Enormous blocks of material broke off during this period and migrated, ever so slowly, along the Pacific plate's northwesterly path. The Salinian block, composed of hard granitic and metamorphic rock, including the whole mass of marble called Pico Blanco, which itself is hundreds of millions of years old, traveled over a thousand miles. Along the way, it collided with the Nacimiento block, part of an accretionary wedge composed of sediments and metamorphic rocks like greenstone, schist, sandstone, and shale. These two blocks, along with smaller terranes that wandered into the area, provided the material that became the central California coast. The whole mass is still creeping northward along the San Andreas fault and is subject to cataclysmic stress. As recently as five million years ago, intense compression along the fault forced the land to fold and buckle. The Santa Lucia mountain range began to rise at that time. Several uplifts, the last less than two million years ago, created the dramatic landscape we now encounter. Subsequent earthquakes, floods, and other shudderings shaped the coast—bringing Thuban, the Altar Stone, and all the other

granite boulders from wherever they had been for the past 130 million years to their places of repose on the hill beside the sea.

Jeffers respected their antiquity. "The heavy granite bodies of the rocks of the headland . . . were ancient here before Egypt had pyramids," he writes in *Hooded Night*. Indeed, "Before the first man / Here were the stones, the ocean, the cypresses." Lifting them from their places, piling them on top of each other to form the walls of his home—"heaping the bones of the old mother / To build us a hold against the host of the air," as he says in *To the House*—was no small matter. In *To the Rock that Will Be a Cornerstone of the House*, he speaks of the centuries that had passed since the last natives had camped nearby. In the interval, he says to the cornerstone, "no one / Touched you with love . . . / Where now my hand lies." To make amends and to consecrate the site on which he was building, he approached the stone with a propitiatory offering: "So I have brought you / Wine and white milk and honey for the hundred years of famine / And the hundred cold ages of sea-wind." The gifts pleased the stone, Jeffers believed, as they mingled "down the storm-worn cracks among the mosses." Admiring the boulder for its great age and remarkable endurance, Jeffers looked forward to years of companionship. "How dear you will be to me," he says, "when I too grow old, old comrade."

The feeling of kinship, as Una says in the letter cited previously, precipitated Jeffers' maturation as an artist. As he carried the boulders and cemented them into place, struggling through a period of emotional upheaval, he found "strengths in himself unknown before," enabling him to break through the last vestiges of youthful self-centeredness and to accept the vicissitudes of life with equanimity. Qualities he found in stone, such as "hardness / And reticence" (*Shine, Republic*) and the ability to shed "pleasure and pain like hail-stones" (*Soliloquy*), were, he realized, characteristics of his own personality, along with coldness, quietness, steadfastness, and a reclusive desire for tranquility. "Those are my people," he says in *The Old Stone-Mason* of the boulders nearby, his family: "Hard heads and stiff wits but faithful, not fools, not chatterers; / And the place where they stand to-day they will stand also to-morrow." And Jeffers planned to stand with them, through life and after death. "Though one at the end of the age and far off from this place / Should meet my presence in a poem," he says in *Post Mortem*, reflecting on his attachment to Carmel Point, "The ghost would not care but be here, long sunset shadow in the seams of the granite, / . . . a spirit for the stone."

Jeffers' feeling of kinship with the granite on Carmel Point served as the basis for his love of the coast. The ocean's ceaseless rhythm, the cries of the gulls and other shorebirds, the scent of seaweed and wildflowers, the fog-

bound chill night air, the moon rising over the mountains—all this became infinitely precious to him, far more important in its permanence and majesty than the cramped, agitated, and transient world of human affairs. Indeed, a key aspect of the awakening that occurred while he was building Tor House was the realization that, within the context of geological time, human life is ephemeral. "Here is reality," he says in *Hooded Night* of the wild landscape around him, "The other is a spectral episode; after the inquisitive animal's / Amusements are quiet: the dark glory."

To truly live, Jeffers concluded, one must break through human self-centeredness, which encourages people to believe they are the raison d'etre of the universe, and bow before the "transhuman magnificence" of the larger world. The reward for those who do so, as Jeffers declares in a speech by Orestes near the close of *The Tower Beyond Tragedy*, is a transcendent experience of oneness and unity.

> I entered the life of the brown forest
> And the great life of the ancient peaks, the patience of stone,
> I felt the changes in the veins
> In the throat of the mountain, a grain in many centuries, we have
> our own time, not yours; and I was the stream
> Draining the mountain wood; and I the stag drinking; and I was
> the stars
> Boiling with light, wandering alone, each one the lord of his own
> summit; and I was the darkness
> Outside the stars, I included them, they were a part of me. I was
> mankind also, a moving lichen
> On the cheek of the round stone . . . they have not made words
> for it, to go behind things, beyond hours and ages,
> And be all things in all time, in their returns and passages, in the
> motionless and timeless center,
> In the white of the fire . . . how can I express the excellence
> I have found, that has no color but clearness;
> No honey but ecstasy; nothing wrought nor remembered; no
> undertone nor silver second murmur
> That rings in love's voice, I and my loved are one; no desire
> but fulfilled; no passion but peace,
> The pure flame and the white, fiercer than any passion; no time
> but spheral eternity. . . .

This illumination led to another, even more profound. In turning toward nature, in learning to see and appreciate the superior "fate going on / Outside our

fates," as he says in *Oh Lovely Rock*, Jeffers encountered God—not the "anthropoid God / Making commandments," the Biblical God of love and wrath and justice who stands outside and above creation, but "the God who does not care and will never cease" (*Explosion*), the God who is the sum and substance of all that is.

"God is a lion that comes in the night," says Jeffers in *The Inhumanist*, searching for images that comprehend the brute power that animates both atoms and galaxies, "God is a hawk gliding among the stars— / If all the stars and the earth, and the living flesh of the night that flows between them, and whatever else is beyond them / Were that one bird." God is like "a great flower of fire on a mountain in the night of victory, he is like a great star that fills all the night, / He is like the music and harmony of all the stars if all their shining were harp-music." Though God "has no righteousness, / No mercy, no love" (*At the Birth of an Age*), he has beauty, heart-rending beauty, which can be seen in the minute particulars which comprise the totality of his being and can be heard as "the one breath of the organ blown through innumerable / Conduits of sound" (*The Women at Point Sur*). For Jeffers, as he declares in *Monument*, there is no qualitative difference between one form of life and another.

> Erase the lines: I pray you not to love classifications:
> The thing is like a river, from source to sea-mouth
> One flowing life. We that have the honor and hardship of being
> human
> Are one flesh with the beasts, and the beasts with the plants
> One streaming sap, and certainly the plants and algae and the earth
> they spring from,
> Are one flesh with the stars. The classifications
> Are mostly a kind of memoria technica, use it but don't be fooled.
> It is all truly one life, red blood and tree-sap,
> Animal, mineral, sidereal, one stream, one organism, one God.

Jeffers' pantheistic vision has much in common with what Huston Smith calls the "Primordial Tradition," an ancient wellspring of wisdom that flows through the esoteric (or mystical) systems of all the world's major religions. Also called the "Perennial Philosophy" or Vedanta, it flows through tribal traditions as well, and through such philosophical movements as Transcendentalism. In a few words, the Primordial Tradition posits a universe created and sustained by an unknowable, incomprehensible, divine force—a Supreme Spirit with no identifiable characteristics. This Spirit, or Absolute God, manifests itself, through subtle shifts of energy, in different planes of existence, the first of which is a level where divine characteristics *can* be seen. Krishna appears here,

as does Shiva, Parvati, Zeus, Athena, Christ, Odin, and all the other gods and goddesses found in humankind's collective pantheon. Beneath this level, there is a zone occupied by demigods, angels, demons, ghosts, and other nonphysical, but nevertheless very active, entities. Finally, there is the natural world, the level of material form, which seems to comprise the lowest end of the cosmic spectrum, the grossest manifestation of divine energy. For those who have eyes to see, however, nature is the primary locus of God's Being. God is not just the creator of the meadowlark flying through the trees or the great whale arching above the waves, God *is* the whale and the meadowlark—and the waves and the trees. There is nothing but God; he/she is all in all.

While Jeffers' vision of the cosmos largely conforms to this schema, it has one important difference that, ultimately, bears upon his understanding of stone. According to the Primordial Tradition, as it appears in most of the world's religions, the God beyond God is infinite, eternal, incorporeal, and immutable. Wanting nothing, knowing everything, self-sufficient and complete, God is absolutely perfect. Because nothing can reduce or impinge upon his experience of perpetual bliss, he is impassible, which means he is completely free from pain. According to Jeffers, however, this is untrue. Since God's body is the material world and God's mind is the awareness of that world, God must live in constant torment. Every star burning its life away in the vast darkness of outer space; every redwood cracked by lightning; every eagle dragging a broken wing; every hunger, desire, fear, wound, or death endured by any entity or organism is a nerve-ending, adding its portion to the sum of God's pain. Indeed, every single atom in the universe is involved in the divine *agon*. "Who feels what God feels," says Jeffers in *The Women at Point Sur*, "Knows the straining flesh, the aching desires . . . the strain of the spinning / Demons that make an atom, straining to fly asunder, / Straining to rest at the center . . . force and counterforce, / Nothing prevails." As he states in a 1936 letter to Rudolph Gilbert, explaining his position in simple terms, "If God is all, he must be suffering, since an unreckoned part of the universe is always suffering." Furthermore, and even more compelling, "his suffering must be self-inflicted, for he is all; there is no one outside him to inflict it."

Prometheus nailed to a mountaintop, Christ on the cross, and Odin hanging from a tree all represent different culture-bound ways of picturing God's self-sacrifice. Above these archetypal configurations, however, and others like them, Jeffers saw a nameless "Hanged God" who willingly endures pain as the price he pays for being. In the concluding pages of *At the Birth of an Age*, Jeffers lets the Hanged God speak—in answer to the endless lamentation that he hears. "Pain

and their endless cries," he says, "How they cry to me: but they are I: let them
ask themselves. / I am they, and there is nothing beside." He then adds,

> I am alone and time passes, time
> also is in me, the long
> Beat of this unquiet heart, the quick drip of this blood, the whirl
> and returning waves of these stars,
> The course of this thought.
> My particles have companions and happy fulfilments, each star
> has stars to answer him and hungry night
> To take his shining, and turn it again and make it a star; each
> beast has food to find and his mating,
> And the hostile and helpful world; each atom has related atoms,
> and hungry emptiness around him to take
> His little shining cry and cry it back; but I am all, the emptiness
> and all, the shining and the night.
> All alone, I alone.

To end the suffering of the world, God would have to end his own solitary life. As
attractive as that option might be, God rejects it—for the sake of self-discovery.

> If I were quiet and emptied myself of pain, breaking
> these bonds
> Healing these wounds: without strain there is nothing. Without
> pressure, without conditions, without pain,
> Is peace; that's nothing, not-being; the pure night, the perfect freedom,
> the black crystal. I have chosen
> Being; therefore wounds, bonds, limits and pain; the crowded mind
> and the anguished nerves, experience and ecstasy.

> Whatever electron or atom or flesh or star or universe cries to me,
> Or endures in shut silence: it is my cry, my silence; I am the nerve,
> I am the agony,
> I am the endurance. I torture myself
> To discover myself; trying with a little or extreme experiment
> each nerve and fibril, all forms
> Of being, of life, of cold substance; all motions and netted complications
> of event,
> All poisons of desire, love, hatred, joy, partial peace, partial vision.
> Discovery is deep and endless,
> Each moment of being is new: therefore I still refrain my burning
> thirst from the crystal-black
> Water of an end.

As his soliloquy draws to a close, the Hanged God acknowledges once again the pain he bears for the sake of existence. Though the "heroic beauty of being" is its own reward, there may come a time when he has had enough. Until then, God pledges to endure—drawing comfort from the peace and quiet, the silence and darkness that also belong to the phenomenal world.

> Every discovery is a
> broken shield, a new knife of consciousness
> Whetted for its own hurt; pain rises like a red river: but also
> the heroic beauty of being,
> That all experience builds higher, the stones are the warring torches,
> towers on the flood. I have not chosen
> To endure eternally; I know not that I shall choose to cease; I have long
> strength and can bear much.
>
> I have also my peace; it is in this mountain. I am this mountain
> that I am hanged on, and I am the flesh
> That suffers on it, I am tortured against the summit of my own peace
> and hanged on the face of quietness.
> I am also the outer nothing and the wandering infinite night.
> These are my mercy and my goodness, these
> My peace. Without the pain, no knowledge of peace, nothing.
> Without the peace,
> No value in the pain. I have long strength.

Insofar as Jeffers' understanding of stone is concerned, these last lines are quite revealing. The process of materialization, whereby God manifests himself in physical form, involves evolution: in nature, life is a battle; ceaseless struggle is the norm. Stone is a part of this battle. It, too, is composed of atoms within which electrons are spinning at wild speeds. It, too, is subject to forces of destruction that wear it away. But stones last longer and burn steadier than anything else. They are "the warring torches" on the front lines of life; as planets, they provide the rampart or tower where life makes its stand. Even more important, the knotted strength of stone, the unflinching endurance, the willingness to accept life as it is—and continue on—shows the way, the only way, to equilibrium and peace.

And this peace, Jeffers realized while building Tor House, as he lifted the hard, cold, indifferent boulders and felt them humming in his hands, is the very peace of God.

IV

The brash wave that took Morley Baer's ashes out to sea no doubt churned them for awhile before flinging them back upon the shore. The ashes are probably still there, on Garrapata Beach near the Black Rock—mixed, in a single handful of sand, with the worn detritus of a thousand other lives: tiny bits of periwinkle shell, limpet, sea star, and hermit crab, feather kelp and rockweed, pelican beak and fish bone, driftwood, pieces of pinecone carried by the creek down from the mountain, thimbleberry seed, the stem of a crimson columbine. Along with the granite, quartz, and feldspar, countless other stones cohere, each having journeyed unknown miles through untold years. It is very easy, if one shares William Blake's sense of mystery, "To see a World" in a single grain of that sand and "Heaven" in a piece of wildflower, to "Hold Infinity in the palm of your hand / And Eternity in an hour" (*Auguries of Innocence*).

Jeffers, of course, shared that sense of mystery. He not only saw a world in a grain of sand, an infinitely small world composed of millions of atoms, he saw the world *as* a grain of sand, itself infinitely small in a cosmos containing trillions of suns. Or, as he says in *Margrave*, even less than that: "the earth is a particle of dust by a sand-grain sun, lost in a nameless cove of the shores of a continent. / Galaxy on galaxy, innumerable swirls of innumerable stars." The stars themselves, in the inconceivable vastness of space and time, are "short-lived as grass," burning up, however long they last, in a single flash. And, as he says in *The Treasure*, despite the enormous eons behind the present moment and all the eons yet to come, "the earth too's an ephemerid," destined, like everything else, to disappear with bewildering swiftness into oblivion. All the more reason, thought Jeffers, to behold earth with compassion. In the words of a late untitled poem, "It is only a little planet / But how beautiful it is."

Baer shared the same sense of mystery—and the feeling of tenderness for the mote that we inhabit, with its massive mountains and fathomless seas. Like Jeffers, living on the edge of the continent, he was attuned to an order and a scale of existence beyond the human; he sought to document the sublime beauty, alien and austere at times, of the natural world, especially that portion of the world he encountered in his beloved Big Sur. A few lines from Jeffers' *De Rerum Virtute* state Baer's convictions as an artist and ask the questions that guided him throughout his career and, finally, inspired *Stones of the Sur*.

One light is left us: the beauty of things, not men;
The immense beauty of the world, not the human world.
Look—and without imagination, desire nor dream—directly
At the mountains and sea. Are they not beautiful?
These plunging promontories and flame-shaped peaks
Stopping the sombre stupendous glory, the storm-fed ocean?
 Look at the Lobos Rocks off the shore,
With foam flying at their flanks, and the long sea-lions
Couching on them. Look at the gulls on the cliff-wind,
And the soaring hawk under the cloud-stream—
 . . . is the earth not beautiful?

A Note on Selection and Organization

In 1929, still in the first uprush of his career, Jeffers journeyed abroad with his wife and sons. The family spent a leisurely six months in England, Ireland, and Scotland visiting sites of historic interest, hiking in the countryside, and exploring miles of seashore. When Jeffers returned home, he published *Descent to the Dead*, a slim volume of verse about the British Isles. Not surprisingly, many of the poems dwell thoughtfully on stones: *Shane O'Neill's Cairn*, *Ossian's Grave*, *The Broadstone*, *The Giant's Ring*, and *In the Hill at New Grange* among them. As beautiful and moving as these poems are, they are not included here. In the same way, except for one instance, stones mentioned in narratives or dramas set in ancient Israel or Greece or the Dark Ages of central Europe are also excluded, as are poems about stone found closer to home, such as *New Mexico Mountain* or *Red Mountain*. Jeffers perceived the same nobility, the same "reticent self-contained self-watchful passion" in stone wherever he looked, but only poems inspired by the Big Sur coast of California are included in this book.

Another principle of exclusion involves sites of significant action. In many of Jeffers' narrative poems, key events take place on hilltops, cliffs, or mountains—"high places," as they are called in comparative religion—or on rocks that are in some sense sacred. In *Tamar*, for instance, the title character attends a séance on the shoreline; when the spirits come, she performs a dance that leaves her feet "dashed with blood where the granite had bruised them." In *Roan Stallion*, a woman named California rides "the savage and exultant strength of the world" to the top of a hill, "the silent calvary" as Jeffers describes it, and finds a measure of mystical union there. Rev. Barclay, the demented minister in *The Women at Point Sur*, repeatedly draws followers up on a mountainside where, like an outlaw Moses, he delivers inflammatory sermons about a wild God. Hood, the young hunter in *Cawdor*, uses "the Rock" at the top of a sheer cliff as a centering sanctuary; knowing this, his jealous father follows him there and, in blind rage, murders him. And Lance Fraser in *Give Your Heart to the Hawks*, having

killed his brother, meets his destiny at Laurel Spring, as foretold by a seer, where he throws himself from the bare rock shoulder of a high and massive ridge. In each of these instances, and in others like them, the site itself—the hill or cliff or mountain—is central to the meaning of the poem. Because the symbolic significance of the site is entwined in larger patterns, however, and because these patterns extend throughout the course of a narrative, it is impossible to select isolated passages that capture the meaning of the whole.

A third category of excluded material involves references to the "stoniness" of people. In addition to observations concerning the stonelike characteristics of his own personality, Jeffers often describes protagonists in lithic terms. When "Passion and despair and grief had stripped away / Whatever is rounded and approachable / In the body of woman," Tamar takes on the appearance of hard "white stone." Faith Heriot struggles with volcanic inner tensions in *The Women at Point Sur*. "If you'd a little knife and you'd nick me here / On the arm or anywhere," she says to her lover, Natalia, "melted stone would run out." Helen Thurso in *Thurso's Landing* repeatedly mocks her husband Reave's stubbornness, saying at one point that he belongs in a circus sideshow where people could "pay ten cents / To see the petrified man" and at another that he is like "one of those predestined stone men / For women to respect and cheat." As the poem unfolds, however, and Reave suffers a crippling injury, Helen comes to admire his stoic endurance of pain. In many ways, Reave is like Lance Fraser whose wife Fayne, studying her tormented husband from afar, thinks he looks like the mountain coast: "All beautiful, with chances of brutal violence; precipitous, dark-natured, . . . without humor, without ever / A glimmer of gayety. . . ." Virtually all of Jeffers' protagonists are, at some point, compared to stone. Indeed, a key to understanding Jeffers' conception of his characters can be found in *An Artist*, a poem about a sculptor who lives alone in the desert and carves "giants in agony" on hidden canyon walls. When pressed for an explanation, the sculptor says he tries "to form in stone the mould of some ideal humanity that might be worthy to *be*," to exist at all, in the lightning-struck beauty of the world. Like Michelangelo's "captives," the sculptor's creations—and Jeffers' protagonists—strive "in dream between stone and life." Their contorted poses and twisted lives reveal the "unbearable consummation" that occurs when, in the painful ecstasy of being, matter and spirit conjoin. As essential as this theme is to an understanding of stone in Jeffers' work, however, it too lies outside the purview of this volume.

What remains, after these three themes are excluded, is an abundance of descriptive and reflective material about the sand, pebbles, boulders, hills, cliffs, and mountains of the Big Sur. In sifting through this material, I have selected

poems and excerpts of poems that capture as much as possible Jeffers' rich phenomenology of stone.

Baer's corpus is also vast. In a professional career that lasted over fifty years, Baer took more than seventeen thousand photographs, most with the same eight-by-ten Ansco View camera. After ruling out his architectural work and setting aside his studies of landscapes outside the central coast of California, a manageable number of images remained. Baer himself picked twenty-six photographs for possible use in this book. Most of them are included here, along with others that reveal similar aesthetic concerns. My final selection was guided by a comment Baer made during one of our conversations about this project. He told me he was persuaded by Jeffers' belief that stone is alive, perhaps even conscious in some way, and that each particular stone, no matter how large or small, has its own personality. Knowing this helped me see additional layers of meaning in specific works—beyond the realism and frankness that first meets the eye. In a few instances, Baer even tries to capture the personalities of stones as revealed in recognizable faces. "Rock Detail, 1951," on page 84, is notable in this regard. When turned clockwise to a vertical position, an impressive visage—grim and knowing—becomes immediately apparent. Baer's totemic Black Rock, also called "South Rock," can be seen in "South Rock, Garrapata Beach, 1967," "Surf Splash, South Rock, 1967," and in the foreground of "Garrapata Beach, March 1964" (pages 100, 110, and 126, respectively).

Stones of the Sur is divided into five parts, each of which takes its title from a poem. Part I, *Tor House*, contains six poems about Jeffers' home, ever the locus of inspiration, along with two photographs. Part II, *Continent's End*, begins with a panoramic view of the coastline. This is followed by visual and textual images that become progressively narrower in scope as Baer and Jeffers focus on the mountains, cliffs, beaches, boulders, rocks, and pebbles of the Big Sur. The inward progression continues in Part III, *Oh Lovely Rock*, where Baer trains his lens on close surfaces—revealing, thereby, his sensibilities at their most abstract. From the middle of Part III on, the spiral is reversed and the view begins to open. Part IV, *Credo*, expands outwardly from the pebbles and rocks of the Big Sur, back to the beaches, cliffs, and mountains. Part V, *The Old Stone-Mason*, concludes the book—with a return to Tor House and Hawk Tower.

Links between the photographs and poems are, in general, thematic. Places mentioned in Jeffers' poems rarely match the sites of Baer's photographs, but a few direct connections, in addition to those concerning Tor House, do occur—as when a poem that mentions the California coastal highway is paired with a photograph that shows the road cutting through the mountains. The intent throughout is to allow word and image to complement, illuminate, and com-

plete each other in order to create one coherent pattern. Sometimes, two excerpts are paired with a single photograph. It should be noted that "Jeffers Country," as the central coast of California is often called, extends beyond the Big Sur proper. Some poems, therefore, refer to Carmel Point, Point Lobos, Point Joe, or other nearby places.

I should mention one additional structural element. Neither Jeffers' poems nor Baer's photographs are arranged chronologically. In Jeffers' case, however, earlier poems preponderate in the first portion of the book. Later poems, such as those that include references to Jeffers' life after Una died or to himself as an old man, are found nearer the end. This explains, in part, the hardening one sees as the aging Jeffers becomes increasingly adamant, both in his vision of the world and in his sense of himself as a man and an artist.

Some poems appear in their entirety while others are excerpted; either way, titles are provided beside each text. A list of poems at the back of the book contains source information: volume and page numbers from *The Collected Poetry of Robinson Jeffers*, edited by Tim Hunt. Titles of photographs appear beneath each plate and in the list of photographs.

PART I
·····························
TOR HOUSE

I am heaping the bones of the old mother
To build us a hold against the host of the air;
Granite the blood-heat of her youth
Held molten in hot darkness against the heart
Hardened to temper under the feet
Of the ocean cavalry that are maned with snow
And march from the remotest west.
This is the primitive rock, here in the wet
Quarry under the shadow of waves
Whose hollows mouthed the dawn; little house each stone
Baptized from that abysmal font
The sea and the secret earth gave bonds to affirm you.

Old garden of grayish and ochre lichen,
How long a time since the brown people who have vanished from here
Built fires beside you and nestled by you
Out of the ranging sea-wind? A hundred years, two hundred,
You have been dissevered from humanity
And only known the stubble squirrels and the headland rabbits,
Or the long-fetlocked plowhorses
Breaking the hilltop in December, sea-gulls following,
Screaming in the black furrow; no one
Touched you with love, the gray hawk and the red hawk touched you
Where now my hand lies. So I have brought you
Wine and white milk and honey for the hundred years of famine
And the hundred cold ages of sea-wind.

I did not dream the taste of wine could bind with granite,
Nor honey and milk please you; but sweetly
They mingle down the storm-worn cracks among the mosses,
Interpenetrating the silent
Wing-prints of ancient weathers long at peace, and the older
Scars of primal fire, and the stone
Endurance that is waiting millions of years to carry
A corner of the house, this also destined.
Lend me the stone strength of the past and I will lend you
The wings of the future, for I have them.
How dear you will be to me when I too grow old, old comrade.

TO THE ROCK
THAT WILL BE
A CORNERSTONE
OF THE HOUSE
. .

TOR HOUSE

. .

If you should look for this place after a handful of lifetimes:
Perhaps of my planted forest a few
May stand yet, dark-leaved Australians or the coast cypress, haggard
With storm-drift; but fire and the axe are devils.
Look for foundations of sea-worn granite, my fingers had the art
To make stone love stone, you will find some remnant.
But if you should look in your idleness after ten thousand years:
It is the granite knoll on the granite
And lava tongue in the midst of the bay, by the mouth of the Carmel
River-valley, these four will remain
In the change of names. You will know it by the wild sea-fragrance of wind
Though the ocean may have climbed or retired a little;
You will know it by the valley inland that our sun and our moon were born
 from
Before the poles changed; and Orion in December
Evenings was strung in the throat of the valley like a lamp-lighted bridge.
Come in the morning you will see white gulls
Weaving a dance over blue water, the wane of the moon
Their dance-companion, a ghost walking
By daylight, but wider and whiter than any bird in the world.
My ghost you needn't look for; it is probably
Here, but a dark one, deep in the granite, not dancing on wind
With the mad wings and the day moon.

TOR HOUSE AND HAWK TOWER, 1964

WINGED ROCK

. .

The flesh of the house is heavy sea-orphaned stone, the imagination of
 the house
Is in those little clay kits of swallows
Hung in the eaves, bright wings flash and return, the heavy rock walls
 commercing
With harbors of the far hills and the high
Rills of water, the river-meadow and the sea-cloud. You have also, O sleepy
 stones,
The red, the white and the marbled pigeons
To beat the blue air over the pinewood and back again in a moment; and
 the bush-hidden
Killdeer-nest against the west wall-foot,
That is fed from many strange ebbs; besides the woodful of finches, the
 shoring gulls,
The sudden attentive passages of hawks.

The fierce musical cries of a couple of sparrowhawks hunting on the
 headland,
Hovering and darting, their heads northwestward,

Prick like silver arrows shot through a curtain the noise of the ocean
Trampling its granite; their red backs gleam
Under my window around the stone corners; nothing gracefuller, nothing
Nimbler in the wind. Westward the wave-gleaners,
The old gray sea-going gulls are gathered together, the northwest wind
 wakening
Their wings to the wild spirals of the wind-dance.
Fresh as the air, salt as the foam, play birds in the bright wind, fly falcons
Forgetting the oak and the pinewood, come gulls
From the Carmel sands and the sands at the river-mouth, from Lobos and
 out of the limitless
Power of the mass of the sea, for a poem
Needs multitude, multitudes of thoughts, all fierce, all flesh-eaters,
 musically clamorous
Bright hawks that hover and dart headlong, and ungainly
Gray hungers fledged with desire of transgression, salt slimed beaks, from
 the sharp
Rock-shores of the world and the secret waters.

INITIALS IN STONE, HAWK TOWER, 1968

Stone-cutters fighting time with marble, you foredefeated
Challengers of oblivion
Eat cynical earnings, knowing rock splits, records fall down,
The square-limbed Roman letters
Scale in the thaws, wear in the rain. The poet as well
Builds his monument mockingly;
For man will be blotted out, the blithe earth die, the brave sun
Die blind and blacken to the heart:
Yet stones have stood for a thousand years, and pained thoughts found
The honey of peace in old poems.

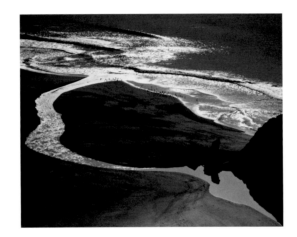

PART II
.............................
CONTINENT'S END

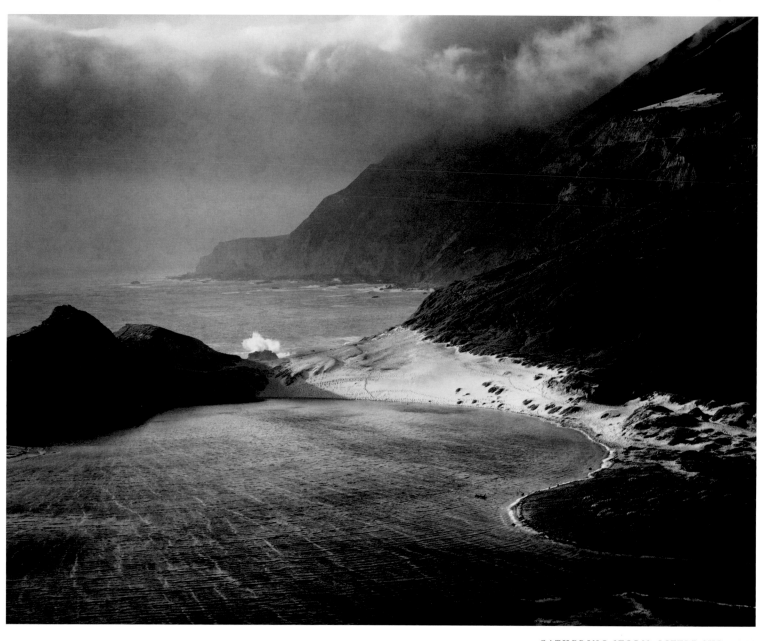

GATHERING STORM, LITTLE SUR, 1972

At the equinox when the earth was veiled in a late rain, wreathed with
 wet poppies, waiting spring,
The ocean swelled for a far storm and beat its boundary, the ground-swell
 shook the beds of granite.

I gazing at the boundaries of granite and spray, the established sea-marks,
 felt behind me
Mountain and plain, the immense breadth of the continent, before me the
 mass and doubled stretch of water.

I said: You yoke the Aleutian seal-rocks with the lava and coral sowings that
 flower the south,
Over your flood the life that sought the sunrise faces ours that has followed
 the evening star.

The long migrations meet across you and it is nothing to you, you have
 forgotten us, mother.
You were much younger when we crawled out of the womb and lay in the
 sun's eye on the tideline.

It was long and long ago; we have grown proud since then and you have
 grown bitter; life retains
Your mobile soft unquiet strength; and envies hardness, the insolent
 quietness of stone.

The tides are in our veins, we still mirror the stars, life is your child, but
 there is in me
Older and harder than life and more impartial, the eye that watched before
 there was an ocean.

That watched you fill your beds out of the condensation of thin vapor and
 watched you change them,
That saw you soft and violent wear your boundaries down, eat rock, shift
 places with the continents.

Mother, though my song's measure is like your surf-beat's ancient rhythm I
 never learned it of you.
Before there was any water there were tides of fire, both our tones flow
 from the older fountain.

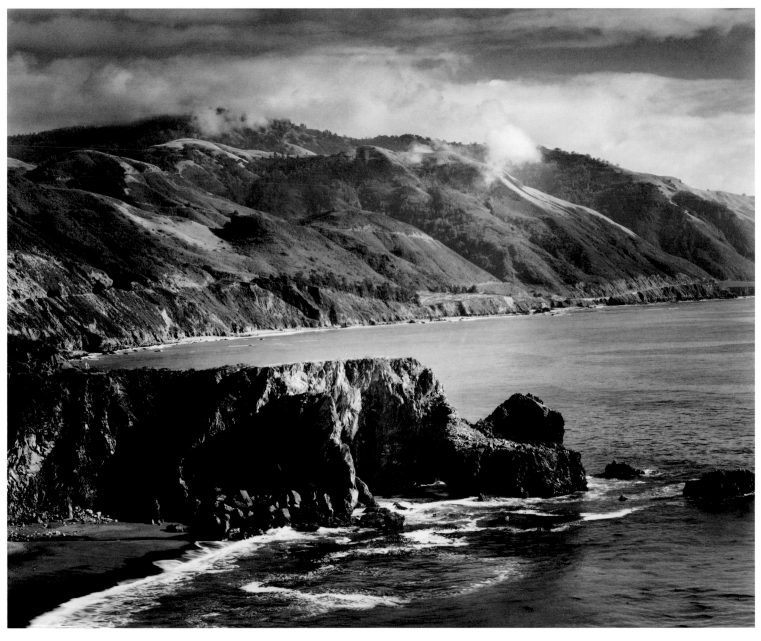

SOUTH SUR COAST, BARREN HILLS WITH ROCK LEDGE, 1991

Gray granite ridges over swinging pits of sea, pink stone-crop spangles
Stick in the stone, the stiff plates of the cypress-boughs divide the sea's
 breath,
Hard green cutting soft gray . . . I know the uplands
And windy pastures where the great globes of the oaks are like green
 planets
Each in his place; I know the scents and resonances of desolate hills,
The wide-winged shadows of the vultures wandering across them; and I
 have visited
Deserts and many-colored rocks . . . mountains I know
From the Dent d'Oche in Savoy and that peak of the south past St.
 Gingolphe
To Grayback and Tahoma . . . as for sea-borderers
The caverned Norman cliffs north of the Seine's mouth, the Breton
 sea-heads, the Cornish
Horns of their west had known me as a child before I knew Point Dume or
 Pinos
Or Sur, the sea-light in his forehead: also I heard my masters
Speak of Pelorum head and the Attic rocks of Sunium, or that Nymphaean
Promontory under the holy mountain Athos, a warren of monks
Walls in with prayer-cells of old stone, perpetual incense and religion
Smoke from it up to him who is greater than they guess, through what
 huge emptiness
And chasms above the stars seeking out one who is here already, and
 neither
Ahunting nor asleep nor in love; and Actium and the Acroceraunian
And Chersonese abutments of Greek ridges on the tideless wave
They named, my spirit has visited . . . there is no place
Taken like this out of deep Asia for a marriage-token, this planted
Asiaward over the west water. Our race nor the great springs we draw from,
Not any race of Europe, nor the Syrian blood from south of Lebanon
Our fathers drank and mixed with ours, has known this place nor its like
 nor suffered

From POINT PINOS AND
POINT LOBOS
. .

The air of its religion. The elder shapes and shows in extreme Asia,
Like remote mountains over immeasurable water, half seen, thought clouds,
Of God in the huge world from the Altai eagle-peaks and Mongol pastures
To the home of snow no wing inhabits, temples of height on earth,
 Gosainthan
And Gaurisankar north of Ganges, Nanda Devi a mast of the ship
We voyage upon among the stars; and the earth-sprung multitudes of India,
Where human bodies grow like weeds out of the earth, and life is nothing,
There is so much life, and like the people the divinities of the people
Swarm, and the vulgar worship; thence far east to the islands of this ocean
Our sun is buried in, theirs born of, to the noble slope of the lone peak
Over Suruga Bay, and the headlands of Hai-nan: God without name,
God without form, the Lord of Asia, is here as there.

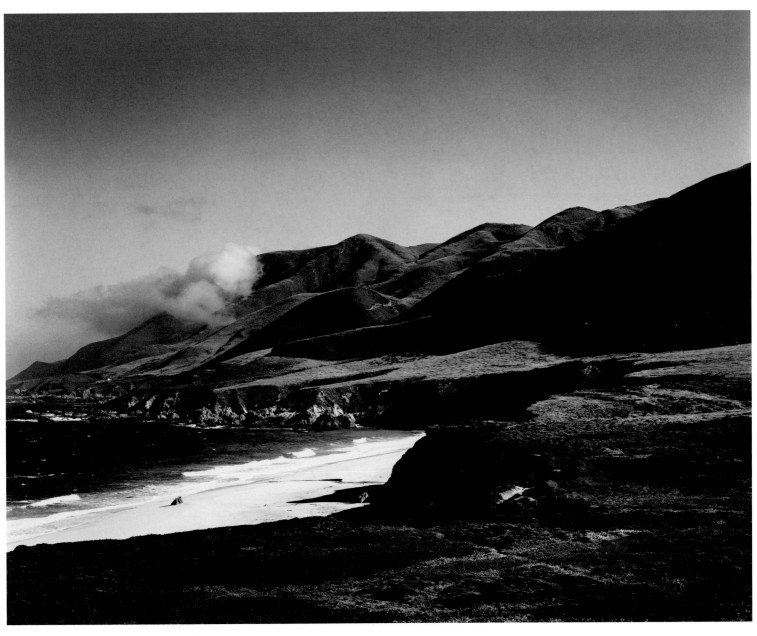

SURF AND HILLS, GARRAPATA, 1965

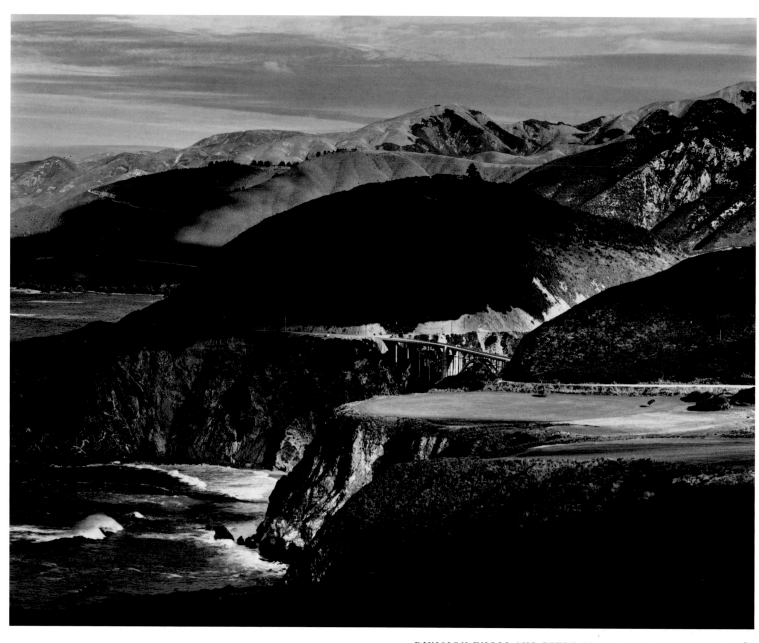

DIVISION KNOLL AND BIXBY CREEK, SUR COAST ROAD, 1982

A horseman high-alone as an eagle on the spur of the mountain over
 Mirmas Canyon draws rein, looks down
At the bridge-builders, men, trucks, the power-shovels, the teeming end of
 the new coast-road at the mountain's base.
He sees the loops of the road go northward, headland beyond headland,
 into gray mist over Fraser's Point,
He shakes his fist and makes the gesture of wringing a chicken's neck,
 scowls and rides higher.

 I too
Believe that the life of men who ride horses, herders of cattle on the
 mountain pasture, plowers of remote
Rock-narrowed farms in poverty and freedom, is a good life. At the far end
 of those loops of road
Is what will come and destroy it, a rich and vulgar and bewildered
 civilization dying at the core,
A world that is feverishly preparing new wars, peculiarly vicious ones, and
 heavier tyrannies, a strangely
Missionary world, road-builder, wind-rider, educator, printer and
 picture-maker and broad-caster
So eager, like an old drunken whore, pathetically eager to impose the
 seduction of her fled charms
On all that through ignorance or isolation might have escaped them. I hope
 the weathered horseman up yonder
Will die before he knows what this eager world will do to his children.
 More tough-minded men
Can repulse an old whore, or cynically accept her drunken kindnesses for
 what they are worth,
But the innocent and credulous are soon corrupted.

 Where is our
 consolation? Beautiful beyond belief
The heights glimmer in the sliding cloud, the great bronze gorge-cut sides
 of the mountain tower up invincibly,
Not the least hurt by this ribbon of road carved on their sea-foot.

THE BEAUTY
OF THINGS
. .

To feel and speak the astonishing beauty of things—earth, stone and
 water,
Beast, man and woman, sun, moon and stars—
The blood-shot beauty of human nature, its thoughts, frenzies and
 passions,
And unhuman nature its towering reality—
For man's half dream; man, you might say, is nature dreaming, but rock
And water and sky are constant—to feel
Greatly, and understand greatly, and express greatly, the natural
Beauty, is the sole business of poetry.
The rest's diversion: those holy or noble sentiments, the intricate ideas,
The love, lust, longing: reasons, but not the reason.

Here is a symbol in which
Many high tragic thoughts
Watch their own eyes.

This gray rock, standing tall
On the headland, where the sea-wind
Lets no tree grow,

Earthquake-proved, and signatured
By ages of storms: on its peak
A falcon has perched.

I think, here is your emblem
To hang in the future sky;
Not the cross, not the hive,

But this; bright power, dark peace;
Fierce consciousness joined with final
Disinterestedness;

Life with calm death; the falcon's
Realist eyes and act
Married to the massive

Mysticism of stone,
Which failure cannot cast down
Nor success make proud.

ROCK AND HAWK
...............................

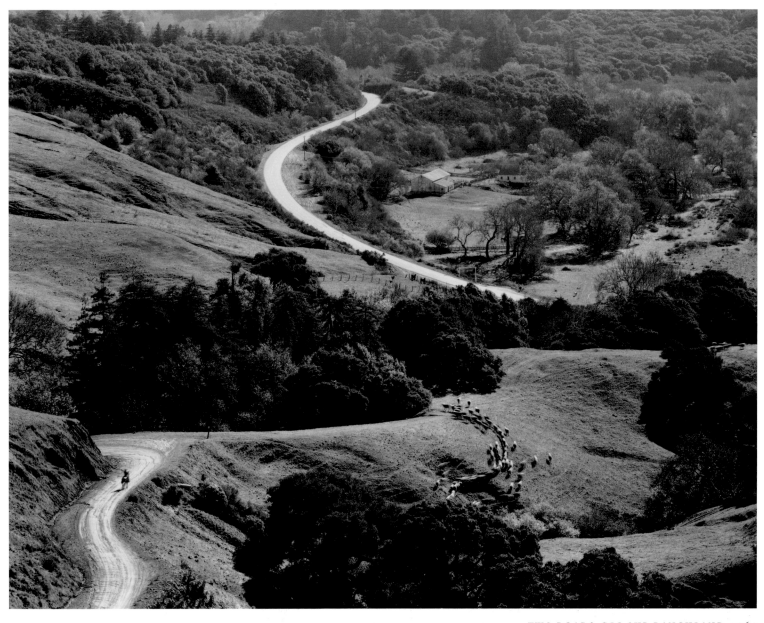

TWO ROADS, BIG SUR RANCHLAND, 1969

This mountain sea-coast is real,
For it reaches out far into past and future;
It is part of the great and timeless excellence of things. A few
Lean cows drift high up the bronze hill;
The heavy-necked plow-team furrows the foreland, gulls tread the furrow;
Time ebbs and flows but the rock remains.

From A LITTLE
SCRAPING
...........................

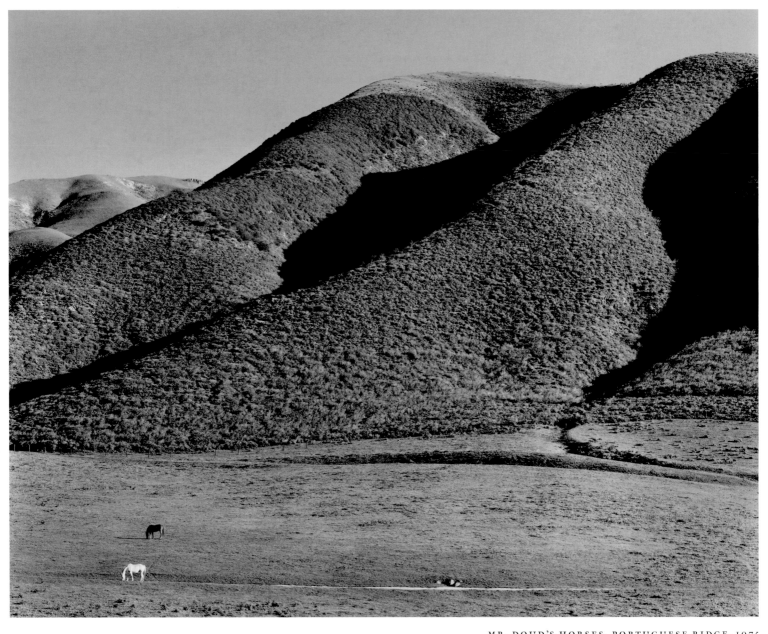

MR. DOUD'S HORSES, PORTUGUESE RIDGE, 1975

 that moment a
heavy
Noise like distant cannon-fire roared at the mountain-top, the horses
 pasturing in the valley below
Raced up the opposite slope; then some great stones and a storm of
 fragments came bounding
Down the rock-face, felled an oak-tree or two, and cut several straight
 paths through the brush and chaparral.
The winter had been very rainy, a high blade of rock
Had settled and split away and rolled down; but it seemed as if the
 mountain had said something, some big word
That meant something, but no one could understand what it meant. Or the
 other mountains did.

From STEELHEAD, WILD
PIG, THE FUNGUS
. .

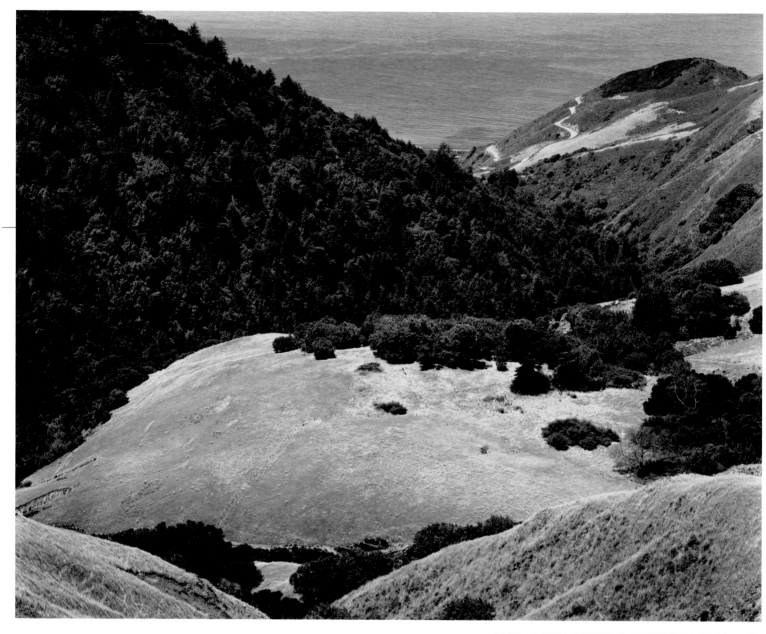

SANTA LUCIA RANGE, NACIMIENTO ROAD, 1963

 the mother-eagle
Hunts her same hills, crying the same beautiful and lonely cry and is never
 tired; dreams the same dreams,
And hears at night the rock-slides rattle and thunder in the throats of these
 living mountains.

From THE BEAKS OF
EAGLES
........................

 The heads of the high redwoods down the deep
 canyon
Rippled, instantly earthquake shook the granite-boned ridge like a rat
In a dog's teeth; the house danced and bobbled, lightning flashed from the
 ground, the deep earth roared, yellow dust
Was seen rising in divers places and rock-slides
Roared in the gorges; then all things were stilled again and the earth stood
 quiet.

From THE INHUMANIST
........................ . . .

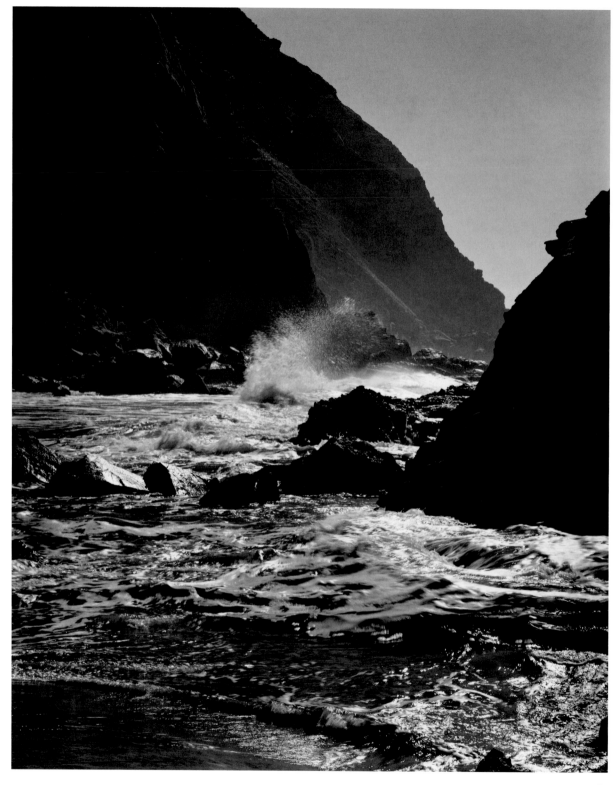

PFEIFFER BEACH, 1985

This coast crying out for tragedy like all beautiful places,
(The quiet ones ask for quieter suffering: but here the granite cliff the
 gaunt cypresses crown
Demands what victim? The dykes of red lava and black what Titan? The
 hills like pointed flames
Beyond Soberanes, the terrible peaks of the bare hills under the sun, what
 immolation?)
This coast crying out for tragedy like all beautiful places

From APOLOGY FOR

BAD DREAMS

.........................

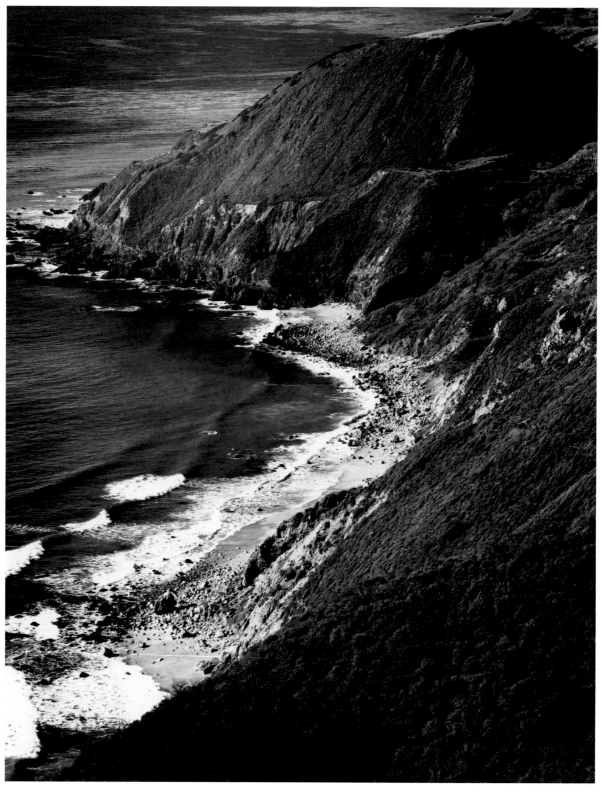

OWINGS BEACH, 1982

I know a narrow beach, a thin tide-line
Of fallen rocks under the foot of the coast-range; the mountain is always
　　sliding; the mountain goes up
Steep as the face of a breaking wave, knuckles of rock, slide-scars, rock-ribs,
　　brush-fur, blue height,
To the hood of cloud. You stand there at the base, perched like a gull on a
　　tilted slab, and feel
The enormous opposed presences; the huge mass of the mountain high
　　overhanging, and the immense
Mass of the deep and sombre Pacific.

From INVASION
. .

I'll tell you
What the world's like: like a stone for no reason falling in the night from a
　　cliff in the hills, that makes a lonely
Noise and a spark in the hollow darkness, and nobody sees and nobody
　　cares.

From THURSO'S
LANDING
. .

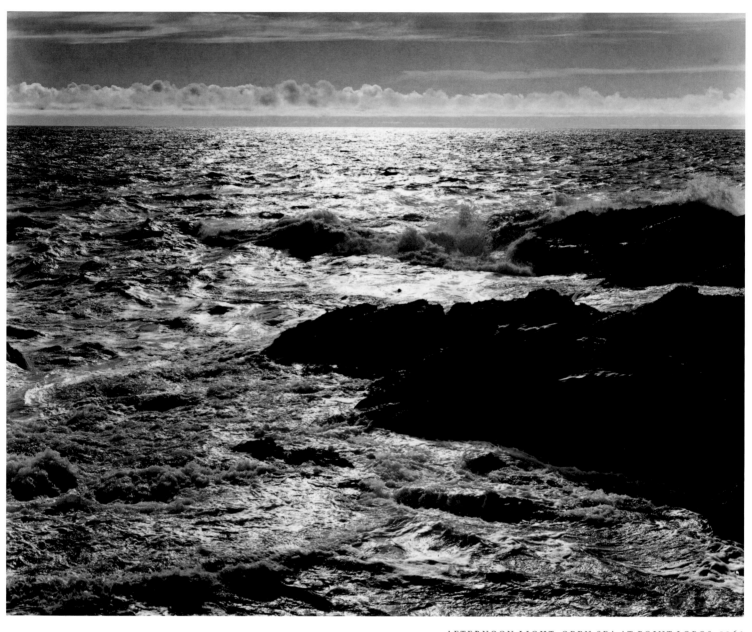

AFTERNOON LIGHT, OPEN SEA AT POINT LOBOS, 1962

Listen: how the air rushes along the keel of the roof, and
 the timbers whining.
That's beautiful; and the hills around here in the cloud-race moon-glimmer,
 round rocks mossed in their cracks with trees:
Can't you see them? I can, as if I stood on them,
And all the coast mountain; and the water-face of the earth, from here to
 Australia, on which thousand-mile storms
Are only like skimming swallows; and the earth, the great meteor-ball of
 live stone, flying
Through storms of sunlight as if forever, and the sun that rushes away we
 don't know where, and all
The fire-maned stars like stallions in a black pasture, each one with his stud
 of plunging
Planets for mares that he sprays with power; and universe after universe
 beyond them, all shining, all alive:
Do you think all *that* needs us?

From GIVE YOUR HEART
TO THE HAWKS

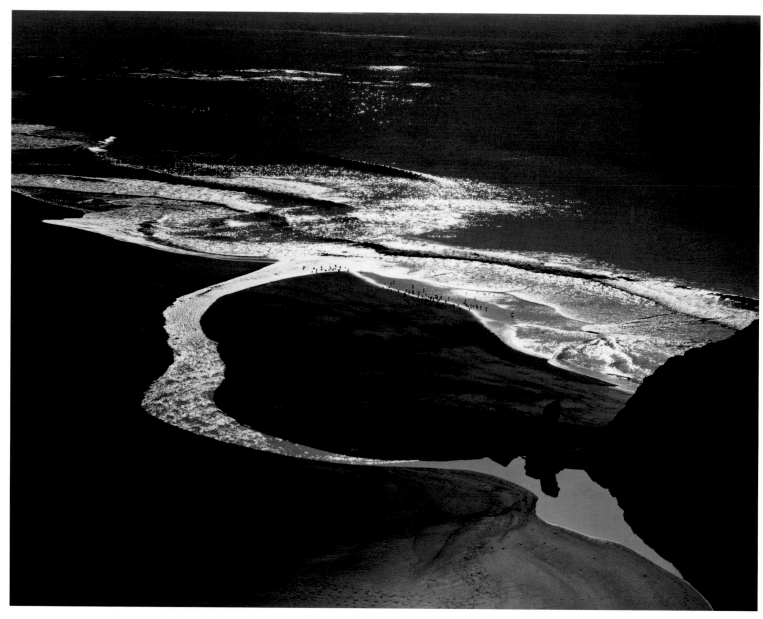

LITTLE SUR, MOUTH OF RIVER, 1969

Ah but look seaward,
For here where the land's charm dies love's chain falls loose, and the
 freedom of the eyes and the fervor of the spirit
Sea-hawks wander the huge gray water, alone in a nihilist simplicity, cleaner
 than the primal
Wings of the brooding of the dove on the waste of the waters beginning,
 perplexed with creation; but ours
Turned from creation, returned from the beauty of things to the beauty of
 nothing, to a nihilist simplicity,
Content with two elements, the wave and the cloud, and if one were not
 there then the other were lovelier to turn to,
And if neither . . . O shining of night, O eloquence of silence, the mother
 of the stars, the beauty beyond beauty,
The sea that the stars and the sea and the mountain bones of the earth and
 men's souls are the foam on, the opening
Of the womb of that ocean.

From POINT PINOS AND
POINT LOBOS
..........................

POINT JOE
. .

Point Joe has teeth and has torn ships; it has fierce and solitary beauty;
Walk there all day you shall see nothing that will not make part of a poem.

I saw the spars and planks of shipwreck on the rocks, and beyond the desolate
Sea-meadows rose the warped wind-bitten van of the pines, a fog-bank vaulted

Forest and all, the flat sea-meadows at that time of year were plated
Golden with the low flower called footsteps of the spring, millions of flowerets,

Whose light suffused upward into the fog flooded its vault, we wandered
Through a weird country where the light beat up from earthward, and was golden.

One other moved there, an old Chinaman gathering seaweed from the sea-rocks,
He brought it in his basket and spread it flat to dry on the edge of the meadow.

Permanent things are what is needful in a poem, things temporally
Of great dimension, things continually renewed or always present.

Grass that is made each year equals the mountains in her past and future;
Fashionable and momentary things we need not see nor speak of.

Man gleaning food between the solemn presences of land and ocean,
On shores where better men have shipwrecked, under fog and among flowers,

Equals the mountains in his past and future; that glow from the earth was only
A trick of nature's, one must forgive nature a thousand graceful subtleties.

 do you remember at all
The beauty and strangeness of this place? Old cypresses
The sailor wind works into deep-sea knots *From* TAMAR
A thousand years; age-reddened granite .
That was the world's cradle and crumbles apieces
Now that we're all grown up, breaks out at the roots;
And underneath it the old gray-granite strength
Is neither glad nor sorry to take the seas
Of all the storms forever and stand as firmly
As when the red hawk wings of the first dawn
Streamed up the sky over it: there is one more beautiful thing,
Water that owns the north and west and south
And is all colors and never is all quiet,
And the fogs are its breath and float along the branches of the cypresses.
And I forgot the coals of ruby lichen
That glow in the fog on the old twigs.

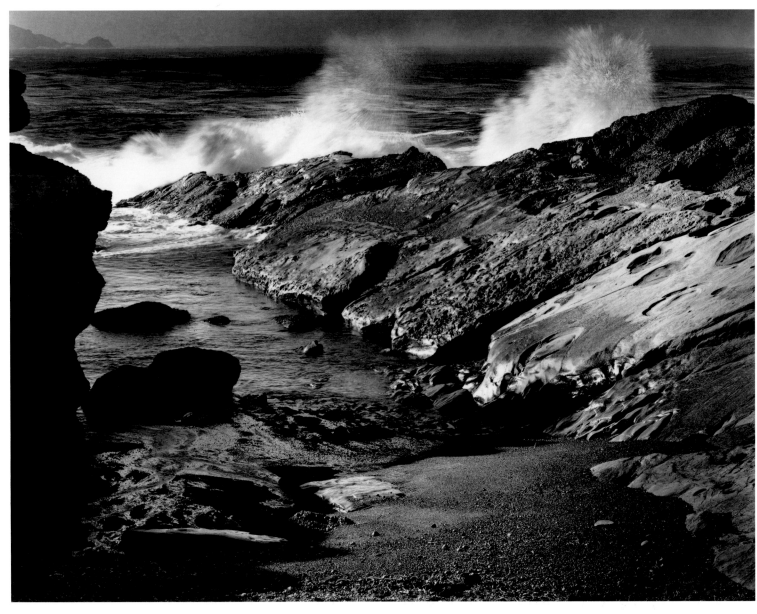

THE SLOT, POINT LOBOS, OCTOBER 1994

Here on the rock it is great and beautiful, here on the foam-wet granite
 sea-fang it is easy to praise
Life and water and the shining stones

From MEDITATION ON
SAVIORS
. .

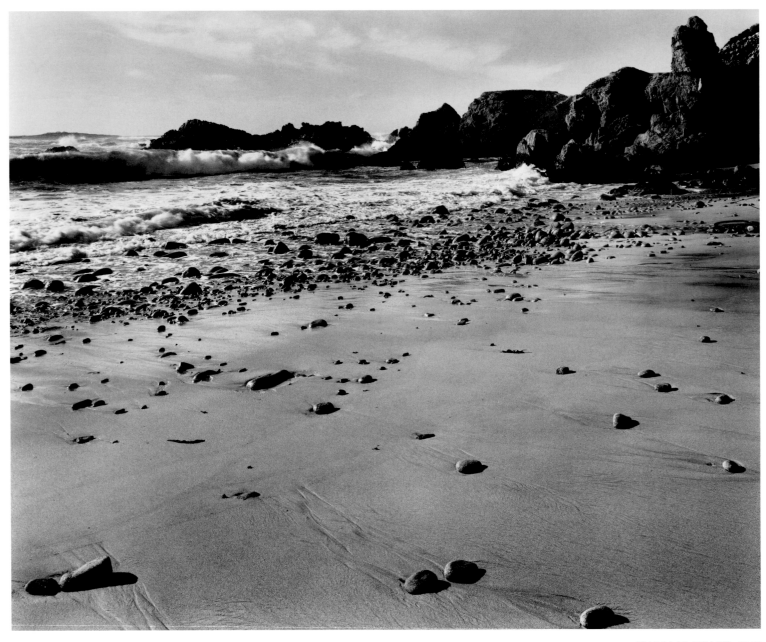

MALPASO BEACH, 1951

Spirits and illusions have died,
The naked mind lives
In the beauty of inanimate things.

Flowers wither, grass fades, trees wilt,
The forest is burnt;
The rock is not burnt.

The deer starve, the winter birds
Die on their twigs and lie
In the blue dawns in the snow.

Men suffer want and become
Curiously ignoble; as prosperity
Made them curiously vile.

But look how noble the world is,
The lonely-flowing waters, the secret-
Keeping stones, the flowing sky.

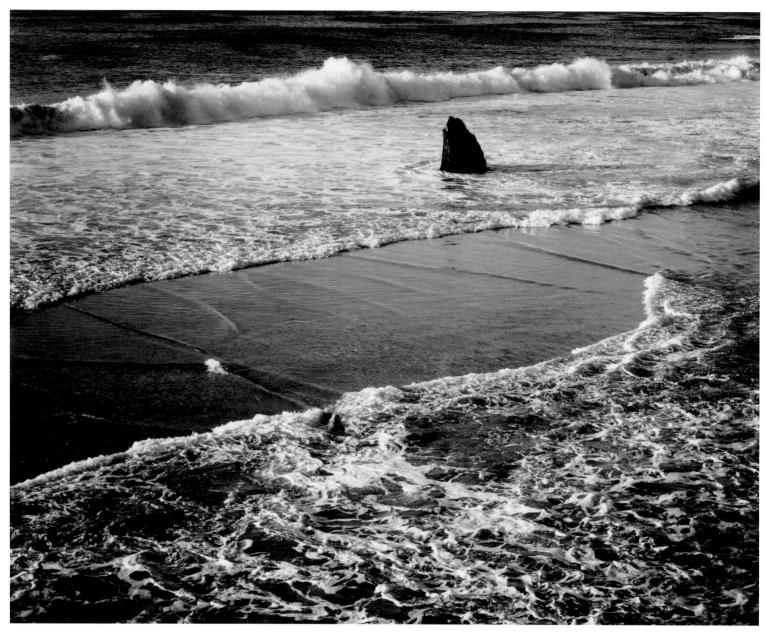

DOUBLE SURF, 1966

The narrow crescent
Of dark gravel, sundered away from the world by its walls of cliff, smoked
 in a burst of sun
And murmured in the high tide through its polished pebbles. The surf
 broke dazzling on fins of rock far out
And foam flowed on the ankles of the precipice.

From THURSO'S
LANDING
. .

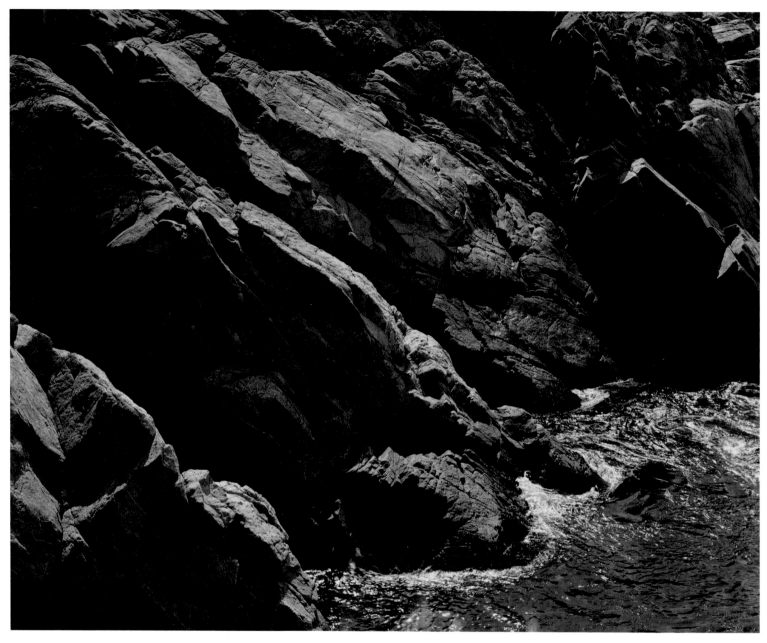

VICTORINE SHORE, 1963

the moon rakes through cloud, the wind pants like a dog and the
 ocean
Tears at his shore, gray claws of a great cat
Slitting the granite.

From NIGHTPIECE
........................

All night long the rush and trampling of water
And hoarse withdrawals, the endless ocean throwing his skirmish-lines
 against granite,
Come to my ears and stop there. I have heard them so long
That I don't hear them—or have to listen before I hear them—How long?
 Forty years.
But that fierce music has gone on for a thousand
Millions of years.

From UNTITLED
........................

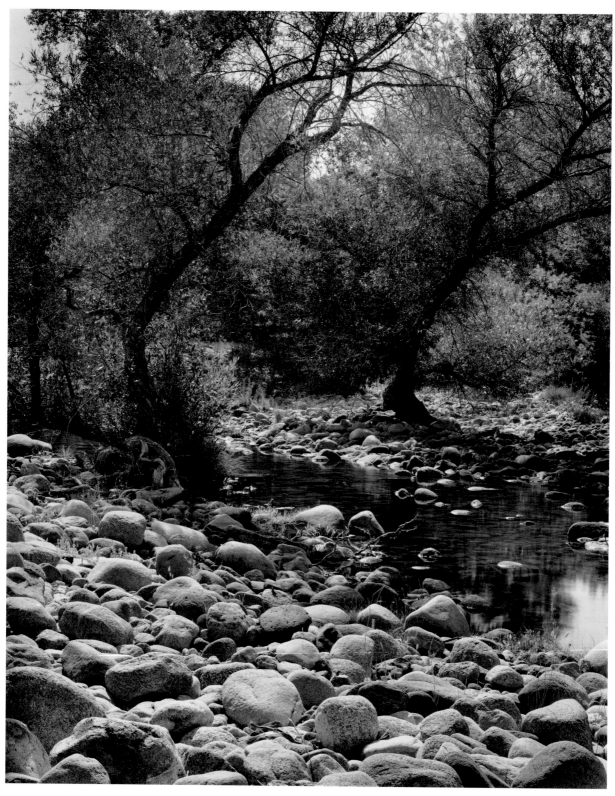

SAN ANTONIO CREEK, 1969

A little too abstract, a little too wise,
It is time for us to kiss the earth again,
It is time to let the leaves rain from the skies,
Let the rich life run to the roots again.
I will go down to the lovely Sur Rivers
And dip my arms in them up to the shoulders.
I will find my accounting where the alder leaf quivers
In the ocean wind over the river boulders.
I will touch things and things and no more thoughts,
That breed like mouthless May-flies darkening the sky,
The insect clouds that blind our passionate hawks
So that they cannot strike, hardly can fly.
Things are the hawk's food and noble is the mountain, Oh noble
Pico Blanco, steep sea-wave of marble.

RETURN

. .

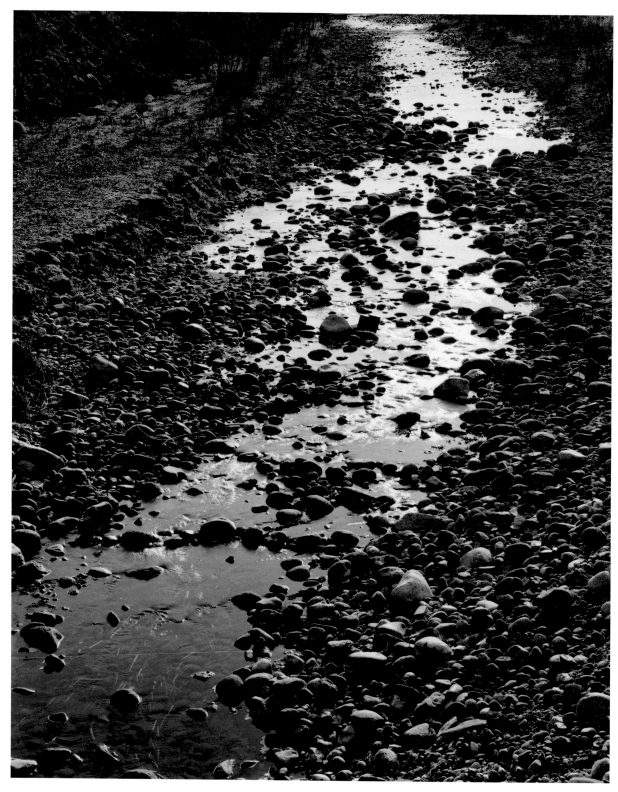

RIVER STONES, 1976

The quietness of stones. *From* ANTE MORTEM

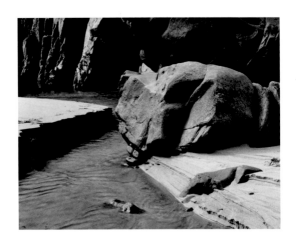

PART III

OH LOVELY ROCK

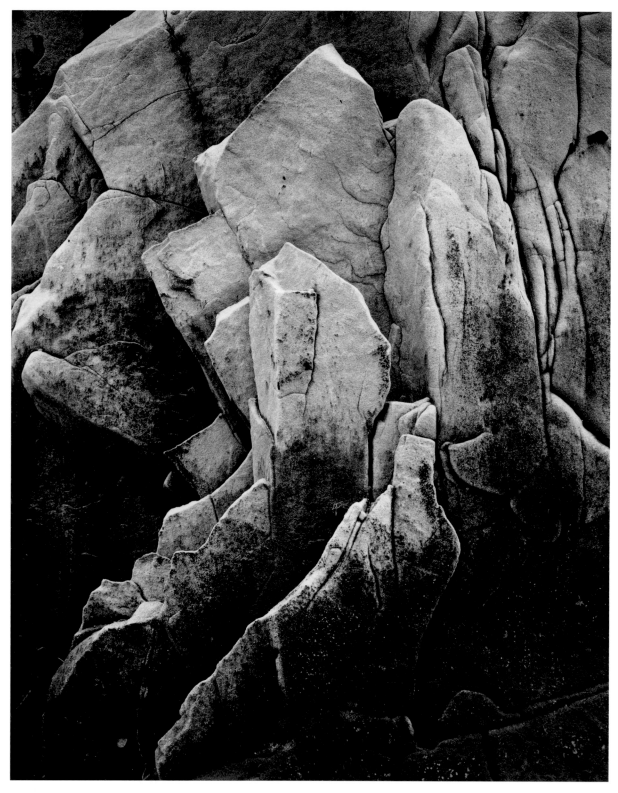

GARRAPATA ROCK DETAIL, JULY 1967

We stayed the night in the pathless gorge of Ventana Creek, up the east
 fork.
The rock walls and the mountain ridges hung forest on forest above our
 heads, maple and redwood,
Laurel, oak, madrone, up to the high and slender Santa Lucian firs that
 stare up the cataracts
Of slide-rock to the star-color precipices.

 We lay on gravel and kept a
 little camp-fire for warmth.
Past midnight only two or three coals glowed red in the cooling darkness; I
 laid a clutch of dead bay-leaves
On the ember ends and felted dry sticks across them and lay down again.
 The revived flame
Lighted my sleeping son's face and his companion's, and the vertical face of
 the great gorge-wall
Across the stream. Light leaves overhead danced in the fire's breath,
 tree-trunks were seen: it was the rock wall
That fascinated my eyes and mind. Nothing strange: light-gray diorite with
 two or three slanting seams in it,
Smooth-polished by the endless attrition of slides and floods; no fern nor
 lichen, pure naked rock . . . as if I were
Seeing rock for the first time. As if I were seeing through the flame-lit
 surface into the real and bodily
And living rock. Nothing strange . . . I cannot
Tell you how strange: the silent passion, the deep nobility and childlike
 loveliness: this fate going on
Outside our fates. It is here in the mountain like a grave smiling child. I
 shall die, and my boys
Will live and die, our world will go on through its rapid agonies of change
 and discovery; this age will die
And wolves have howled in the snow around a new Bethlehem: this rock
 will be here, grave, earnest, not passive: the energies
That are its atoms will still be bearing the whole mountain above: and I
 many packed centuries ago
Felt its intense reality with love and wonder, this lonely rock.

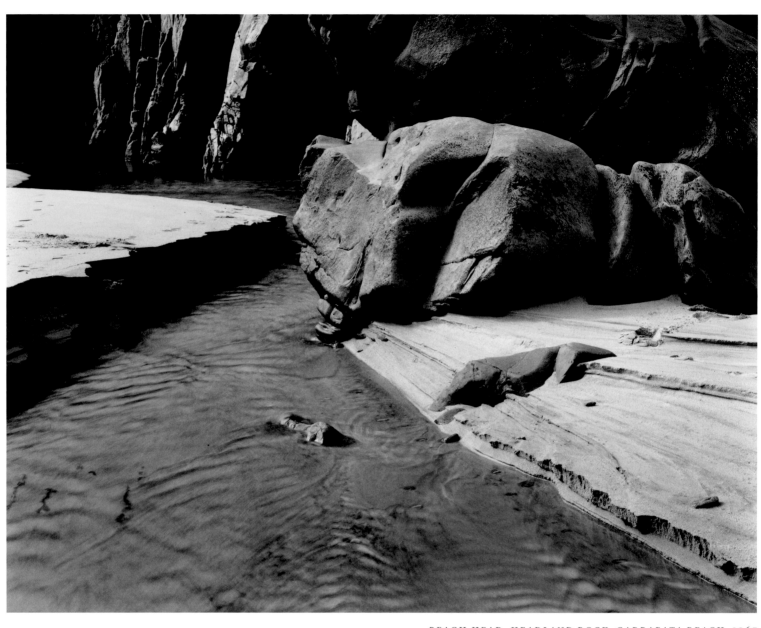

BEACH HEAD, HEADLAND ROCK, GARRAPATA BEACH, 1967

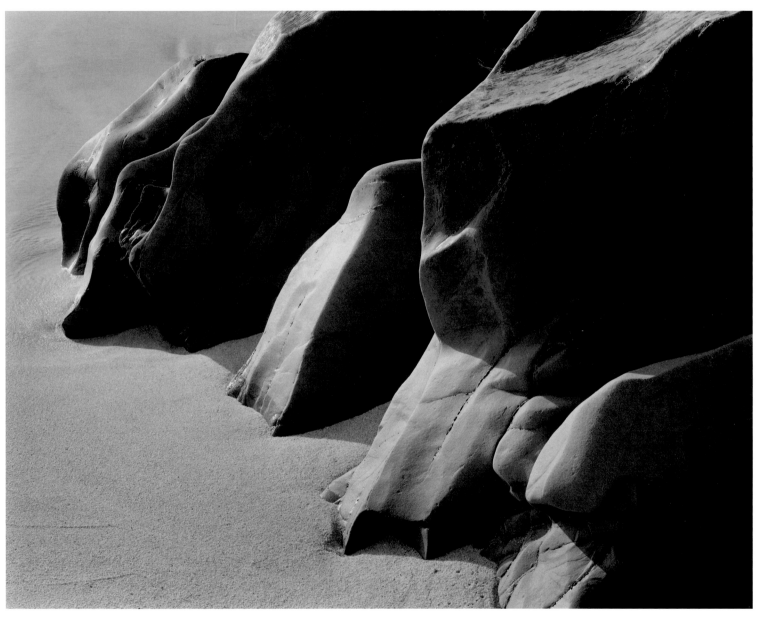

TIDAL ROCK, GARRAPATA BEACH, 1969

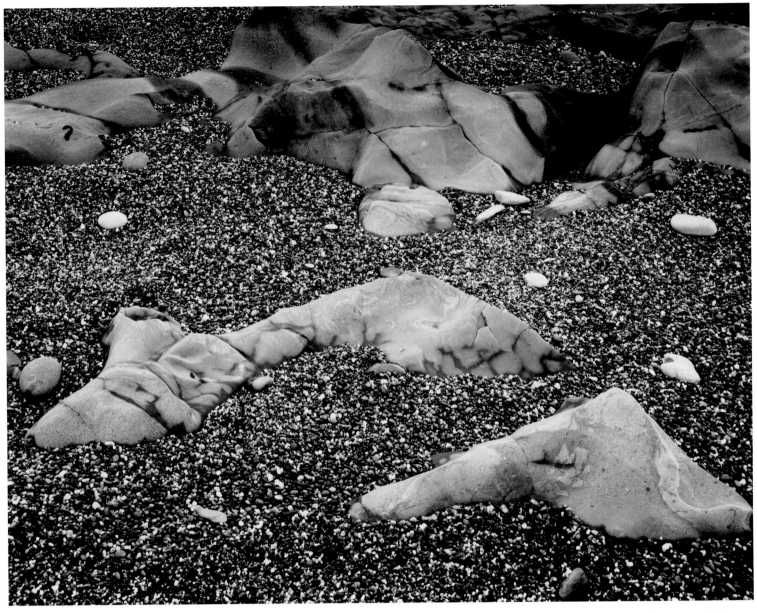

ROCK DETAIL, 1985

It is true that, older than man and ages to outlast him, the Pacific surf
Still cheerfully pounds the worn granite drum;
But there's no storm; and the birds are still, no song; no kind of excess;
Nothing that shines, nothing is dark;
There is neither joy nor grief nor a person, the sun's tooth sheathed in
 cloud,
And life has no more desires than a stone.
The stormy conditions of time and change are all abrogated, the essential
Violences of survival, pleasure,
Love, wrath and pain, and the curious desire of knowing, all perfectly
 suspended.
In the cloudy light, in the timeless quietness,
One explores deeper than the nerves or heart of nature, the womb or soul,
To the bone, the careless white bone, the excellence.

GRAY WEATHER

...........................

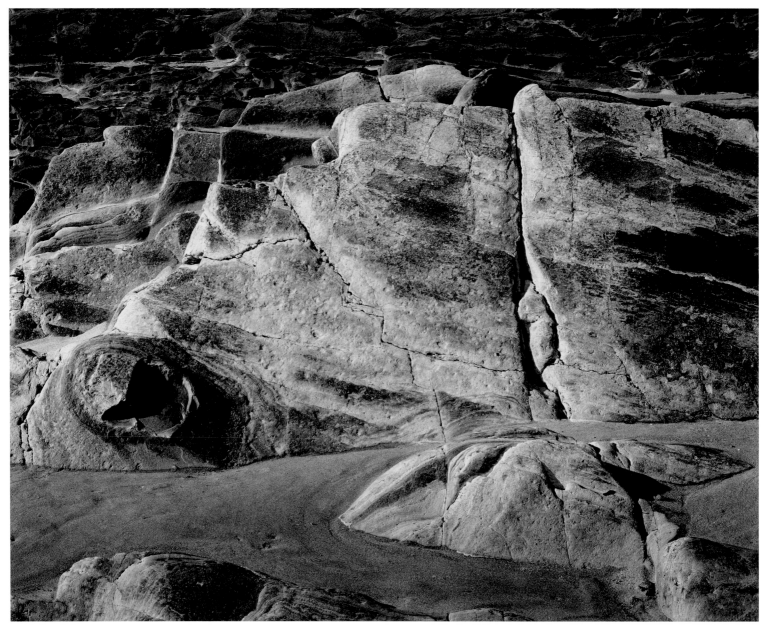

ROCK DETAIL, 1951

 The strained peace
Of the rock has no repose, it is wild and shuddering, it travels *From* CAWDOR
In the teeth of locked strains unimaginable paths; . . .
It is full of desire; but the brittle iniquities of pleasure
And pain are not there.

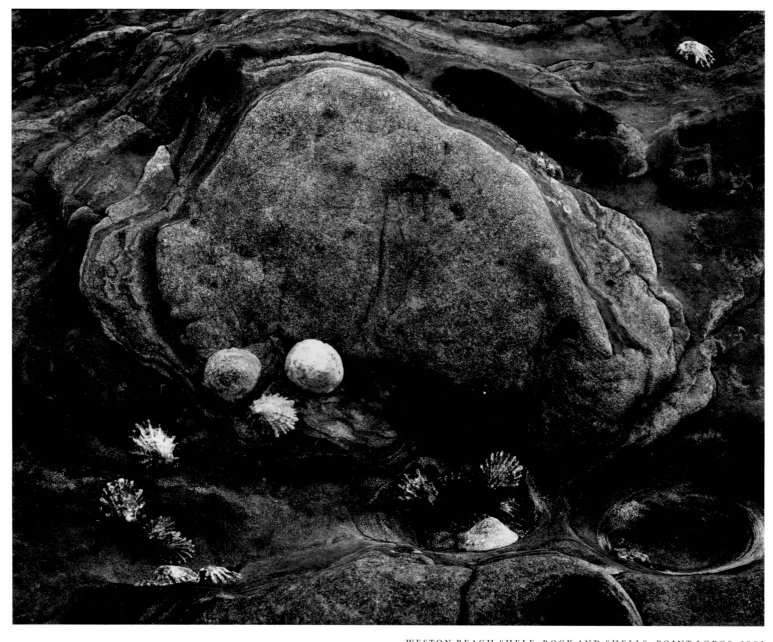

WESTON BEACH SHELF, ROCK AND SHELLS, POINT LOBOS, 1993

"Does God exist?—No doubt of that," the old man says. "The cells of my
 old camel of a body,
Because they feel each other and are fitted together,—through nerves and
 blood feel each other,—all the little animals
Are the one man: there is not an atom in all the universes
But feels every other atom; gravitation, electromagnetism, light, heat, and
 the other
Flamings, the nerves in the night's black flesh, flow them together; the stars,
 the winds and the people: one energy,
One existence, one music, one organism, one life, one God: star-fire and
 rock-strength, the sea's cold flow
And man's dark soul."

From THE INHUMANIST
.........................

You would be wise, you far stars,
To flee with the speed of light this infection.
For here the good sane invulnerable material
And nature of things more and more grows alive and cries.
The rock and water grow human, the bitter weed
Of consciousness catches the sun, it clings to the near stars,
Even the nearer portion of the universal God
Seems to become conscious, yearns and rejoices
And suffers: I believe this hurt will be healed
Some age of time after mankind has died,
Then the sun will say "What ailed me a moment?" and resume
The old soulless triumph, and the iron and stone earth
With confident inorganic glory obliterate
Her ruins and fossils, like that incredible unfading red rose
Of desert in Arizona glowing life to scorn,
And grind the chalky emptied seed-shells of consciousness
The bare skulls of the dead to powder; after some million
Courses around the sun her sadness may pass:
But why should you worlds of the virgin distance
Endure to survive what it were better to escape?

I also am not innocent
Of contagion, but have spread my spirit on the deep world.
I have gotten sons and sent the fire wider.
I have planted trees, they also feel while they live.
I have humanized the ancient sea-sculptured cliff
And the ocean's wreckage of rock
Into a house and a tower,
Hastening the sure decay of granite with my hammer,
Its hard dust will make soft flesh;

And have widened in my idleness
The disastrous personality of life with poems,
That are pleasant enough in the breeding but go bitterly at last
To envy oblivion and the early deaths of nobler
Verse, and much nobler flesh;
And I have projected my spirit
Behind the superb sufficient forehead of nature
To gift the inhuman God with this rankling consciousness.

But who is our judge? It is likely the enormous
Beauty of the world requires for completion our ghostly increment,
It has to dream, and dream badly, a moment of its night.

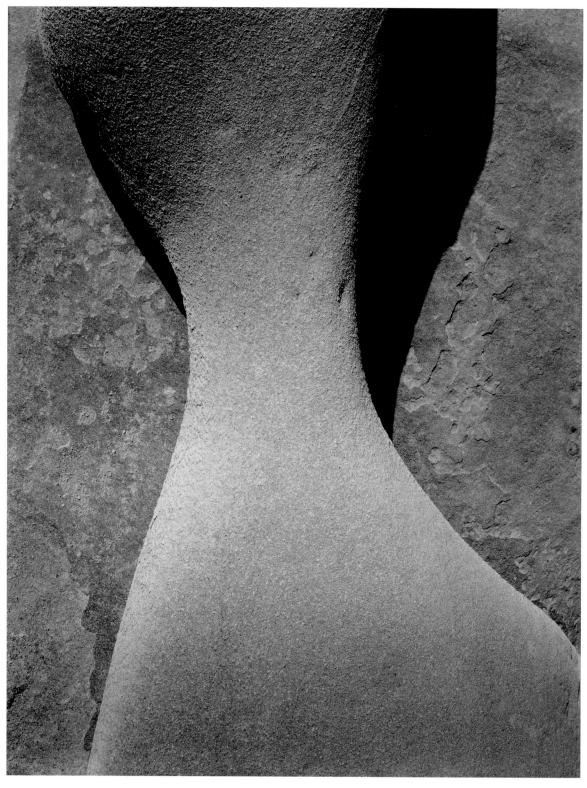

ROCK TORSO, POINT LOBOS, 1947

Civilized, crying how to be human again: this will tell you how.
Turn outward, love things, not men, turn right away from humanity,
Let that doll lie. Consider if you like how the lilies grow,
Lean on the silent rock until you feel its divinity
Make your veins cold, look at the silent stars, let your eyes
Climb the great ladder out of the pit of yourself and man.
Things are so beautiful, your love will follow your eyes;
Things are the God, you will love God, and not in vain,
For what we love, we grow to it, we share its nature. At length
You will look back along the stars' rays and see that even
The poor doll humanity has a place under heaven.
Its qualities repair their mosaic around you, the chips of strength
And sickness; but now you are free, even to become human,
But born of the rock and the air, not of a woman.

SIGN-POST
........................

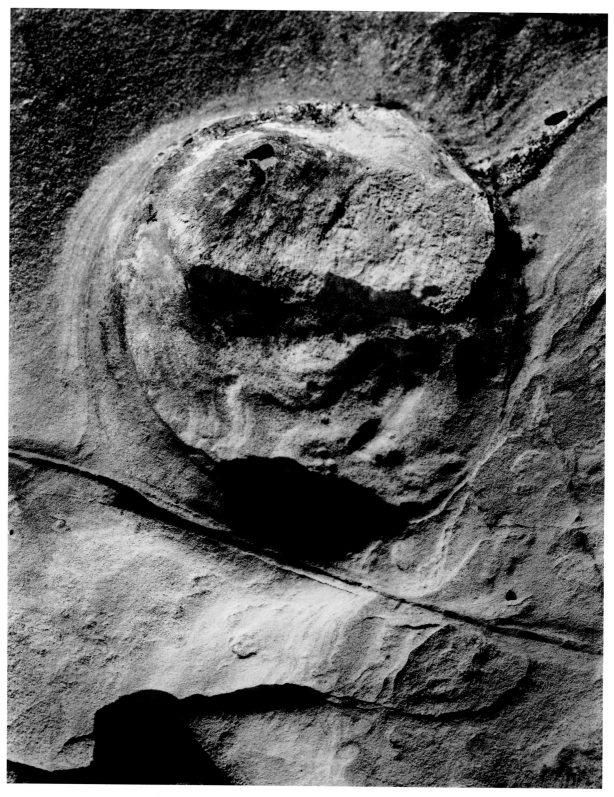

THE SLOT, ERODED ROCK CIRCLE, 1992

What is this thing called life?—But I believe

That the earth and stars too, and the whole glittering universe, and rocks

 on the mountain have life,

Only we do not call it so—I speak of the life

That oxydizes fats and proteins and carbo-

Hydrates to live on, and from that chemical energy

Makes pleasure and pain, wonder, love, adoration, hatred and terror: how

 do these things grow

From a chemical reaction?

 I think they were here already. I think the

 rocks

And the earth and the other planets, and the stars and galaxies

Have their various consciousness, all things are conscious;

But the nerves of an animal, the nerves and brain

Bring it to focus; the nerves and brain are like a burning-glass

To concentrate the heat and make it catch fire:

It seems to us martyrs hotter than the blazing hearth

From which it came. So we scream and laugh, clamorous animals

Born howling to die groaning: the old stones in the dooryard

Prefer silence: but those and all things have their own awareness,

As the cells of a man have; they feel and feed and influence each other, each

 unto all,

Like the cells of a man's body making one being,

They make one being, one consciousness, one life, one God.

From UNTITLED

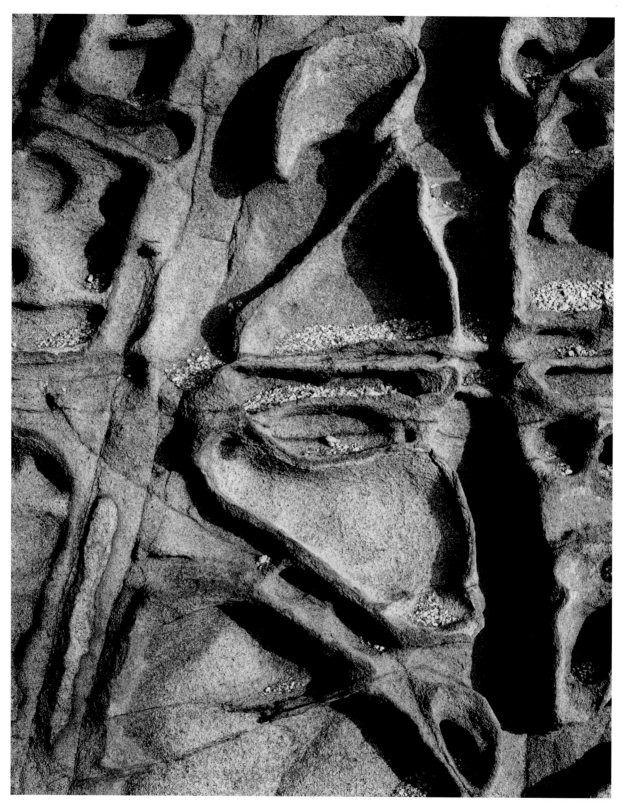

SALT ERODED ROCK, GARRAPATA BEACH, 1966

The rock shining dark rays and the rounded
Crystal the ocean his beam of blackness and silence
Edged with azure, bordered with voices;
The moon her brittle tranquillity; the great phantoms, the fountains of
 light, the seed of the sky,
Their plaintive splendors whistling to each other:
There is nothing but shines though it shine darkness; nothing but answers;
 they are caught in the net of their voices
Though the voices be silence; they are woven in the nerve-warp.
One people, the stars and the people, one structure; the voids between
 stars, the voids between atoms, and the vacancy
In the atom in the rings of the spinning demons,
Are full of that weaving; one emptiness, one presence

From THE WOMEN AT
POINT SUR
........................

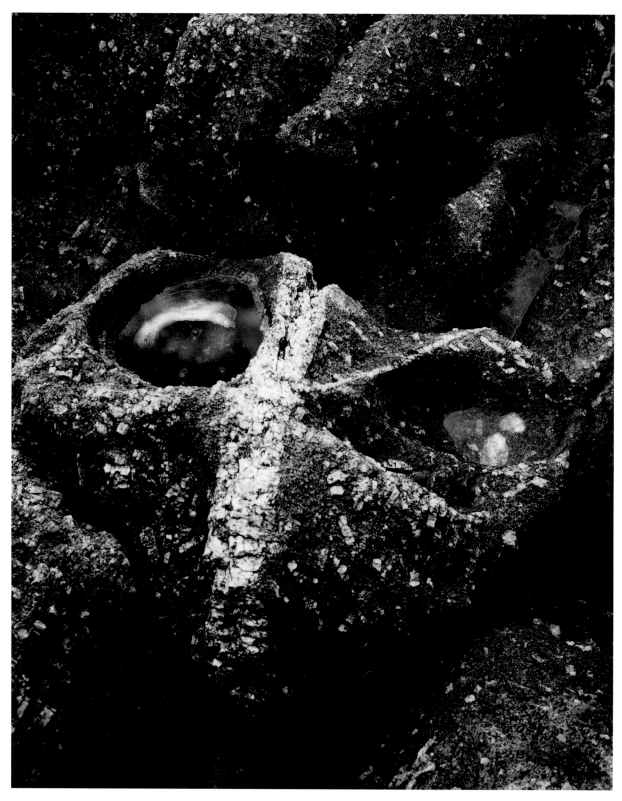

JEFFERS' ROCK, 1962

Dear God, who are the whole splendor of things and the sacred stars, but
 also the cruelty and greed, the treacheries
And vileness, insanities and filth and anguish: now that this thing comes
 near us again I am finding it hard
To praise you with a whole heart.

From CONTEMPLATION
OF THE SWORD

 I know what pain is, but pain can
 shine. I know what death is, I have sometimes
Longed for it. But cruelty and slavery and degradation, pestilence, filth, the
 pitifulness
Of men like little hurt birds and animals . . . if you were only
Waves beating rock, the wind and the iron-cored earth, the flaming insolent
 wildness of sun and stars,
With what a heart I could praise your beauty.

 You will not repent, nor
 cancel life, nor free man from anguish
For many ages to come. You are the one that tortures himself to discover
 himself: I am
One that watches you and discovers you, and praises you in little parables,
 idyl or tragedy, beautiful
Intolerable God.

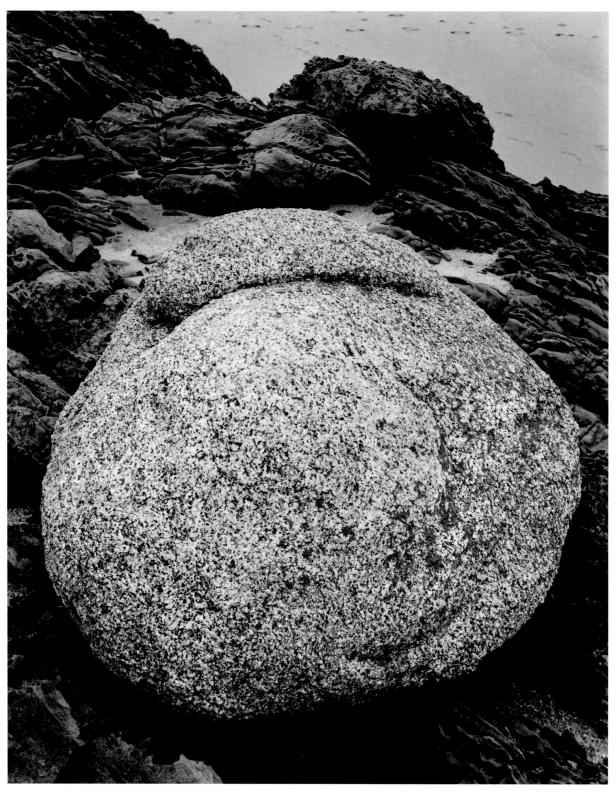

GARRAPATA LEDGE ROCK, 1966

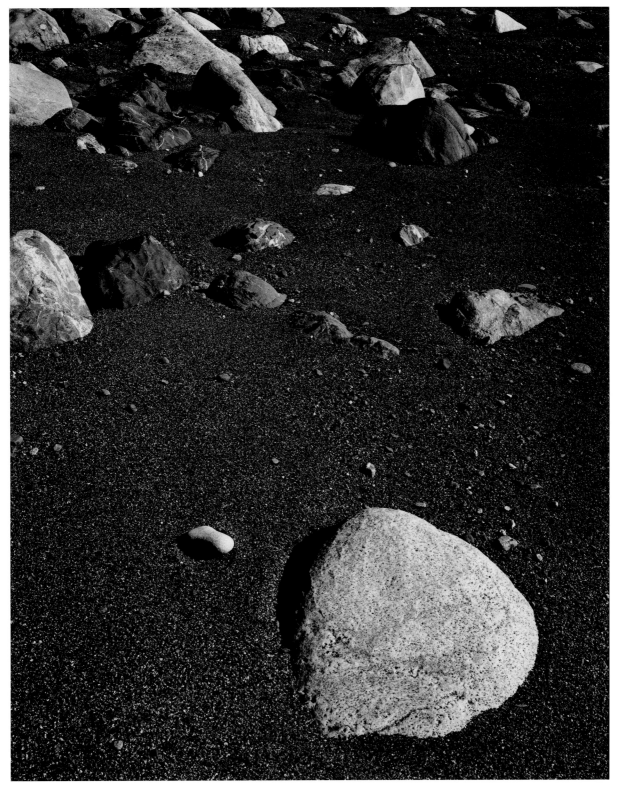

BIG CREEK ROCKS, 1970

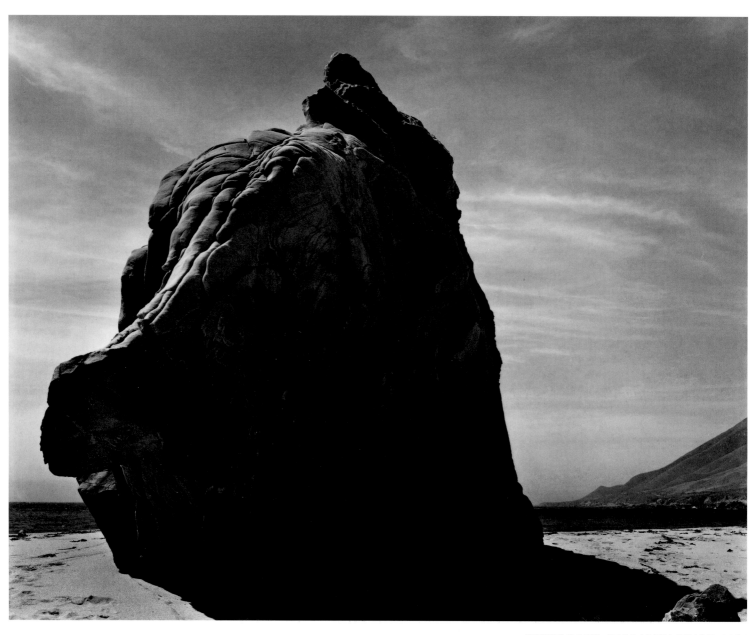

SOUTH ROCK, GARRAPATA BEACH, 1967

"And nothing," he thought,
"Is not alive." He had been down to the sea and hooked a rock-cod and was
 riding home: the high still rocks
Stood in the canyon sea-mouth alert and patient, waiting a sign perhaps;
 the heavy dark stooping hills
Shouldered the cloud, bearing their woods and streams and great loads of
 time: "I see that all things have souls.
But only God's is immortal. The hills dissolve and are liquidated; the stars
 shine themselves dark."

From THE INHUMANIST
........................

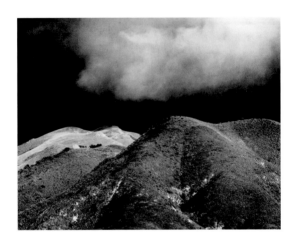

PART IV
. .
CREDO

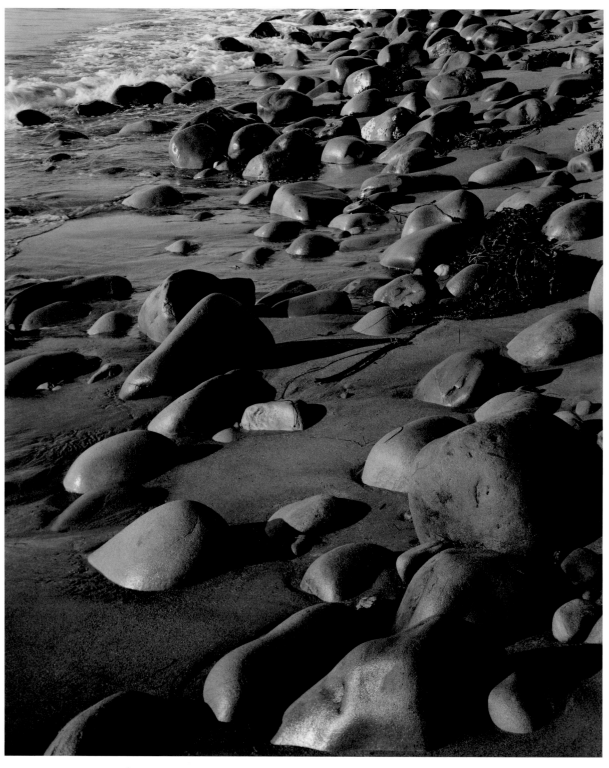

BEACH STONES, 1956

Here is the dignity
We adored in rocks and waters, the reticent self-contained self-watchful
 passion of the gray rock

From AT THE BIRTH
OF AN AGE
. .

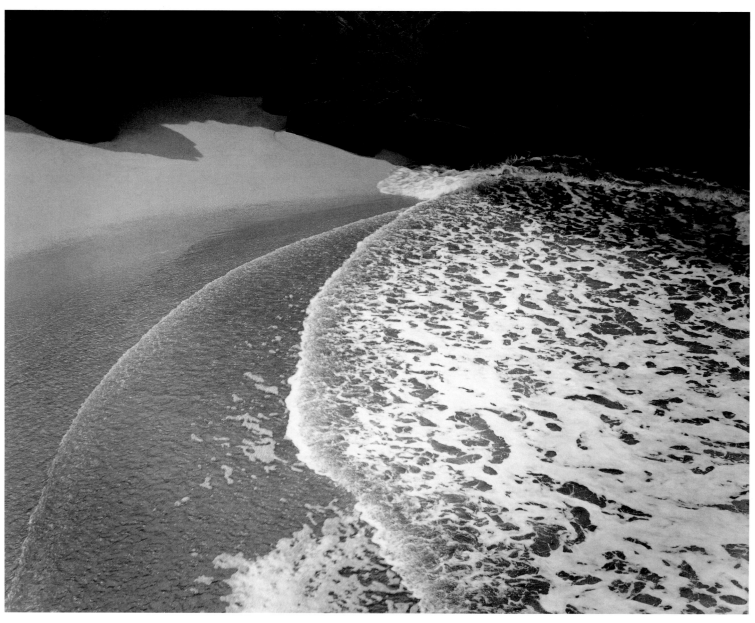

TIDAL WASH, GARRAPATA CANYON, 1967

 When deepening twilight
Made all things gray and made trespass safe, Clare entered
The seaward fields with her flock. They had fed scantly
In the redwood forest, and here in the dead grass
The cattle had cropped all summer they could not sleep.
She led them hour after hour under the still stars.
Once they ran down to the glimmering beach to avoid
The herd and the range bull; they returned, and wandered
The low last bluff, where sparse grass labors to live in the wind-heaped
 sand. Silently they pastured northward,
Gray file of shadows, between the glimmer and hushing moan of the ocean
 and the dark silence of the hills.
The erect one wore a pallor of starlight woven in her hair. Before moonrise
 they huddled together
In a hollow cup of old dune that opened seaward, but sheltered them from
 the nightwind and from morning eyes.

The bleating of sheep answered the barking of sea-lions and Clare awoke
Dazzled in the broad dawn. The land-wind lifted the light-spun manes of
 the waves, a drift of sea-lions
Swung in the surf and looked at the shore, sleek heads uplifted and great
 brown eyes with a glaze of blind
Blue sea-light in them. "You lovely creatures," she whispered.
She went to the verge and felt the foam at her ankles. "You lovely creatures
 come closer." The sheep followed her
And stopped in the sand with lonesome cries. Clare stood and trembled at
 the simple morning of the world; there was nothing
But hills and sea, not a tree on the shore nor a ship on the sea; an edge of
 the hill kindled with gold,
And the sun rose. Then Clare took home her soul from the world and went
 on.

From THE LOVING
SHEPHERDESS
. . . .

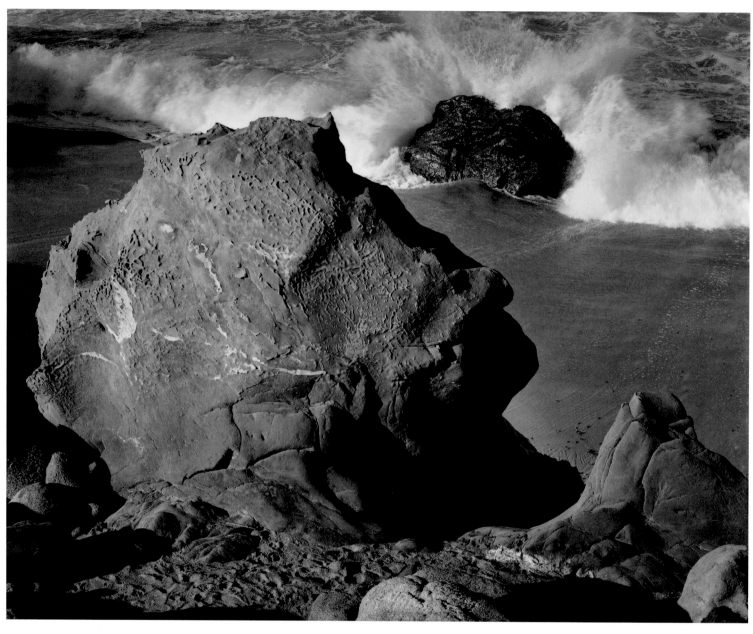

SCROLL ROCK AND SURF, 1975

In youth I thought I could live without pleasure as the stones live their
 being; they do not need pleasure for bait.
Well—I've none now. Pleasure? There is no pleasure.
I have grown old. My wife has died, I can never see her again, nor speak to
 her; my dogs have died.
My friends, if I ever had any friends, have died.
Let me lie under ocean-surf, like the cold stones.
But I lied when I said
I have no pleasure. There is on the lowest level, lower than animal,
The pleasure of drinking whiskey, and to watch the world
Totter above its grave, and to hear the madmen
Who direct nations—I do not say that I could do it
More wisely; I say the world's on a precipice edge
Where every act, forward or backward, is fatal,
And wise counsel's a fool. I enjoy that a little.
Perhaps the other animals will make a new world
When mankind's out.

PLEASURES

There is a higher pleasure:
To lie among the cold stones my older brothers—God knows I am old
 enough,
But not like granite—to lie quietly embarnacled
Under the film of surf and look at the sky.
I strain the mind to imagine distances
That are not in man's mind: the planets, the suns, the galaxies, the
 super-galaxies, the incredible voids
And lofts of space: our mother the ape never suckled us
For such a forest: The vastness here, the horror, the mathematical
 unreason, the cold awful glory,
The inhuman face of our God: It is pleasant and beautiful.

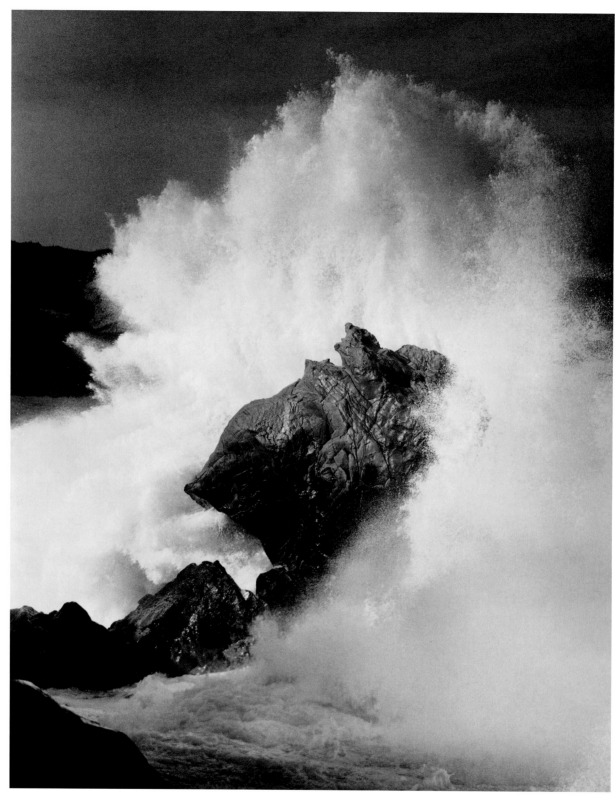

SURF SPLASH, SOUTH ROCK, 1967

 Dark and

 enormous *From* THE

Rolls the surf of the far storms of the heart of the ocean; TORCH-BEARERS' RACE

The old granite breaks into white torches the heavy-shouldered children of .

 the wind

 The calm and large

Pacific surge heavy with summer rolling southeast from a far origin *From* TAMAR

Battered to foam among the stumps of granite below. .

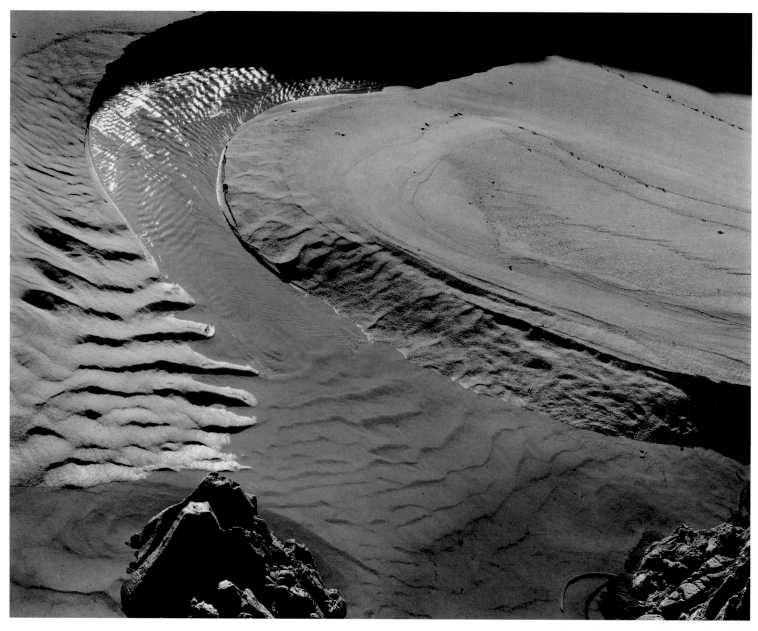

GARRAPATA CREEK, 1975

That Nova was a moderate star like our good sun; it stored no doubt a
 little more than it spent
Of heat and energy until the increasing tension came to the trigger-point
Of a new chemistry; then what was already flaming found a new manner of
 flaming ten-thousandfold
More brightly for a brief time; what was a pin-point fleck on a sensitive
 plate at the great telescope's
Eye-piece now shouts down the steep night to the naked eye, a nine-day
 super-star.

 It is likely our moderate
Father the sun will sometime put off his nature for a similar glory. The
 earth would share it; these tall
Green trees would become a moment's torches and vanish, the oceans
 would explode into invisible steam,
The ships and the great whales fall through them like flaming meteors into
 the emptied abysm, the six-mile
Hollows of the Pacific sea-bed might smoke for a moment. Then the earth
 would be like the pale proud moon,
Nothing but vitrified sand and rock would be left on earth. This is a
 probable death-passion
For the sun's planets; we have no knowledge to assure us it may not happen
 at any moment of time.

Meanwhile the sun shines wisely and warm, trees flutter green in the wind,
 girls take their clothes off
To bathe in the cold ocean or to hunt love; they stand laughing in the
 white foam, they have beautiful
Shoulders and thighs, they are beautiful animals, all life is beautiful. We
 cannot be sure of life for one moment;
We can, by force and self-discipline, by many refusals and a few assertions,
 in the teeth of fortune assure ourselves
Freedom and integrity in life or integrity in death. And we know that the
 enormous invulnerable beauty of things
Is the face of God, to live gladly in its presence, and die without grief or
 fear knowing it survives us.

NOVA

..........................

CARMEL POINT

. .

The extraordinary patience of things!
This beautiful place defaced with a crop of suburban houses—
How beautiful when we first beheld it,
Unbroken field of poppy and lupin walled with clean cliffs;
No intrusion but two or three horses pasturing,
Or a few milch cows rubbing their flanks on the outcrop rock-heads—
Now the spoiler has come: does it care?
Not faintly. It has all time. It knows the people are a tide
That swells and in time will ebb, and all
Their works dissolve. Meanwhile the image of the pristine beauty
Lives in the very grain of the granite,
Safe as the endless ocean that climbs our cliff.—As for us:
We must uncenter our minds from ourselves;
We must unhumanize our views a little, and become confident
As the rock and ocean that we were made from.

Every October millions of little fish come along the shore,
Coasting this granite edge of the continent

On their lawful occasions: but what a festival for the sea-fowl.
What a witches' sabbath of wings
Hides the dark water. The heavy pelicans shout "Haw!" like Job's warhorse
And dive from the high air, the cormorants
Slip their long black bodies under the water and hunt like wolves
Through the green half-light. Screaming the gulls watch,
Wild with envy and malice, cursing and snatching. What hysterical greed!
What a filling of pouches! the mob-
Hysteria is nearly human—these decent birds!—as if they were finding
Gold in the street. It is better than gold,
It can be eaten: and which one in all this fury of wildfowl pities the fish?
No one certainly. Justice and mercy
Are human dreams, they do not concern the birds nor the fish nor eternal
 God.
However—look again before you go.
The wings and the wild hungers, the wave-worn skerries, the bright quick
 minnows
Living in terror to die in torment—
Man's fate and theirs—and the island rocks and immense ocean beyond,
 and Lobos
Darkening above the bay: they are beautiful?
That is their quality: not mercy, not mind, not goodness, but the beauty of
 God.

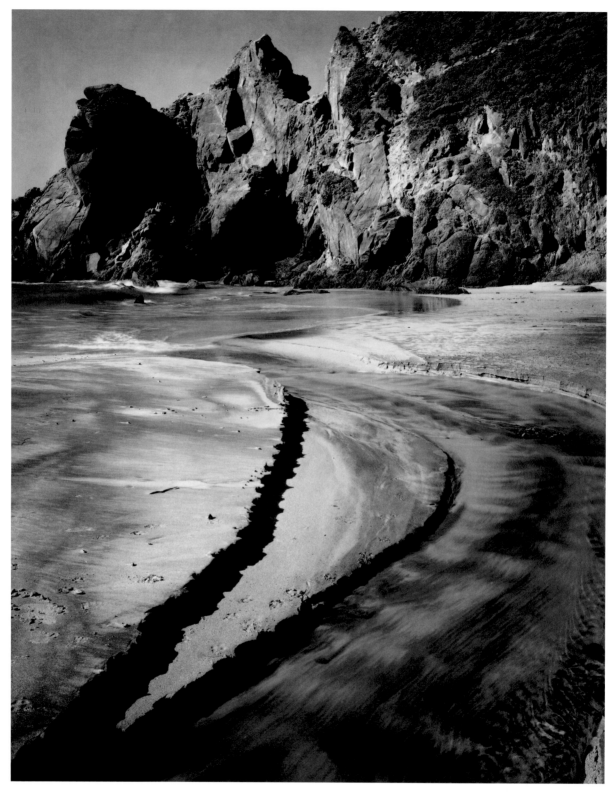

PFEIFFER BEACH, BIG SUR, 1981

the mountains are alive. They crouch like great cats watching
Our comic and mousehole tragedies, or lift high over them
Peaks like sacred torches, pale-flaming rock.
The old blue dragon breathes at their feet, the eternal flames
Burn in the sky. The spirit that flickers and hurts in humanity
Shines brighter from better lamps; but from all shines.
Look to it: prepare for the long winter: spring is far off.

From MARA
.........................

Nobler than man or beast my sea-mountains
Pillar the cloud-sky; the beautiful waters in the deep gorges,
Ventana Creek and the Sur Rivers, Mal Paso Creek, Soberanes, Garapatas,
　　Palo Colorado,
Flow, and the sacred hawks and the storms go over them. Man's fate is like
　　Eastern fables, startling and dull,
The Thousand and One Nights, or the jabber of delirium:—what of it?
　　What is not well? Man is not well? What of it?
He has had too many doctors, leaders and saviors: let him alone. It may be
　　that bitter nature will cure him.

From WHAT OF IT?
.........................

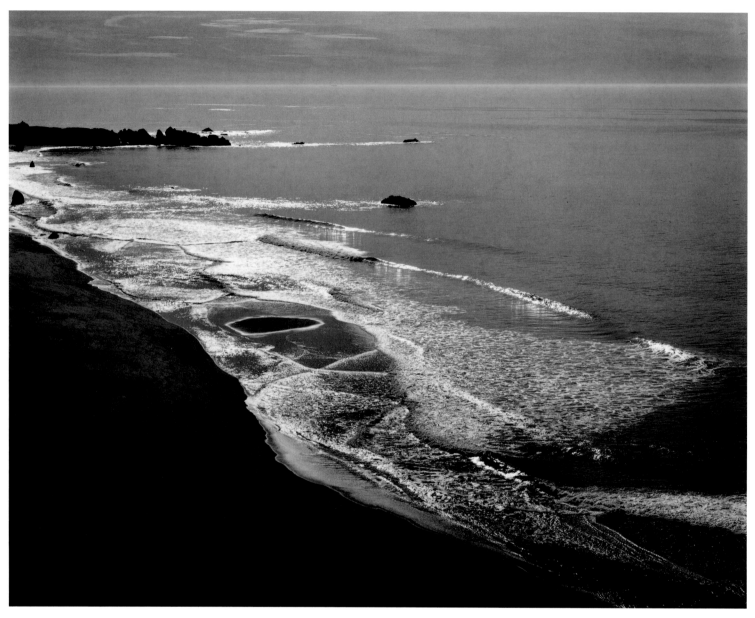

SUMMER SEA, 1968

The ocean has not been so quiet for a long while; five night-herons
Fly shorelong voiceless in the hush of the air
Over the calm of an ebb that almost mirrors their wings.
The sun has gone down, and the water has gone down
From the weed-clad rock, but the distant cloud-wall rises. The ebb
 whispers.
Great cloud-shadows float in the opal water.

From EVENING EBB
. .

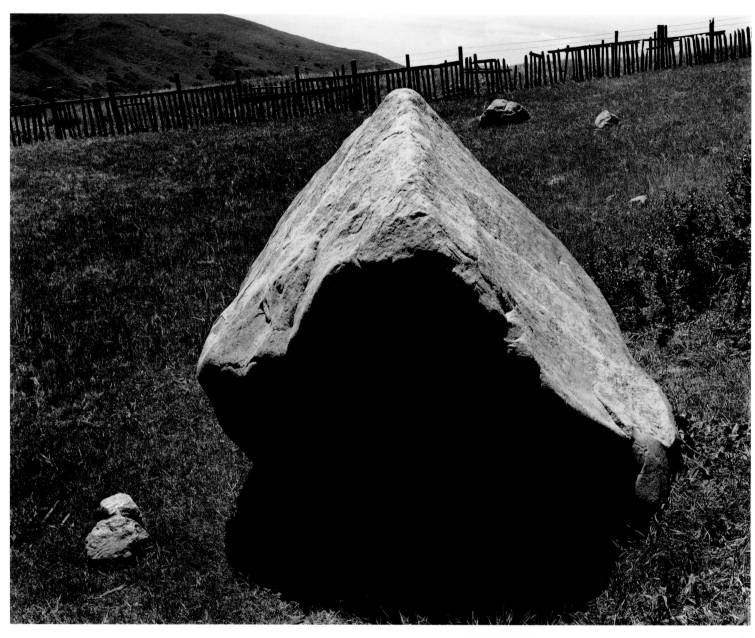

FIELD ROCK WITH FENCE, OLD COAST ROAD, 1987

 all greatness

Involves betrayal, of the people by a man
Or of a man by the people. Better to have stood *From* GREAT MEN
Forever alone. Better been mute as a fish,
Or an old stone on the mountain, where no man comes
But only the wilderness-eyeing hawk with her catch
And feeds in peace, delicately, with little beakfuls,
While far down the long slope gleams the pale sea.

 Oh rich

Clean turbulent wind arching the house-roof,
Roaring in the creekside redwoods, tearing the mountain oaks: you living *From* SUCH COUNSELS
 mountains, YOU GAVE TO ME
Palo Corona and the ancient forest, Mount Carmel, Pico Blanco, Ventanas,
 high heads
With clear snow heavy to-night, and you sea-wall ridges and the streaming
 waters, tall granite rocks
Burly-shouldered standing watchful in pastures:
I never imagined that you can pity humanity;
You ought to pity us, perverse by nature, you are the blessed ones.
I know that you neither hear nor care, but your presence helps,
One endures extreme evil more nobly in your presence.
You are sane and stone; humanity is crafty and cruel and mad.

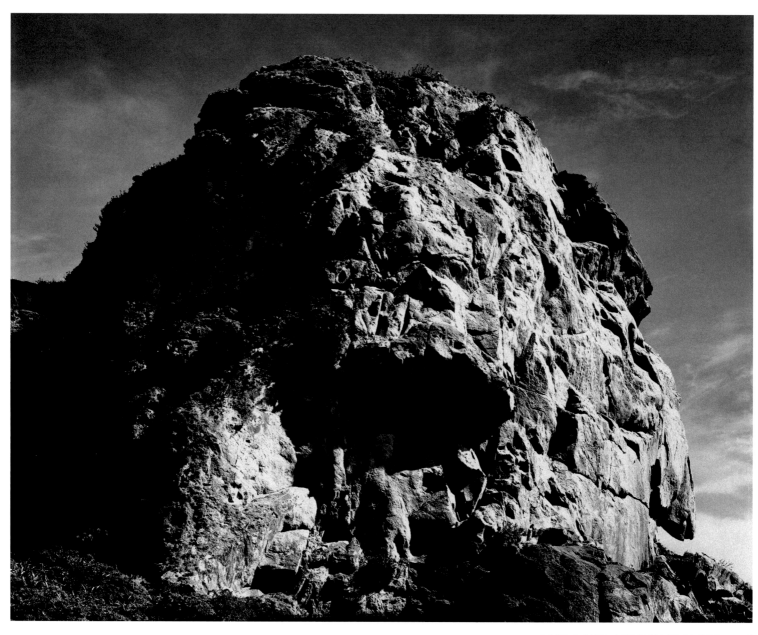

GOLD ROCK, GARRAPATA CREEK, 1976

Though joy is better than sorrow joy is not great;
Peace is great, strength is great.
Not for joy the stars burn, not for joy the vulture
Spreads her gray sails on the air
Over the mountain; not for joy the worn mountain
Stands, while years like water
Trench his long sides. "I am neither mountain nor bird
Nor star; and I seek joy."
The weakness of your breed: yet at length quietness
Will cover those wistful eyes.

JOY

........................

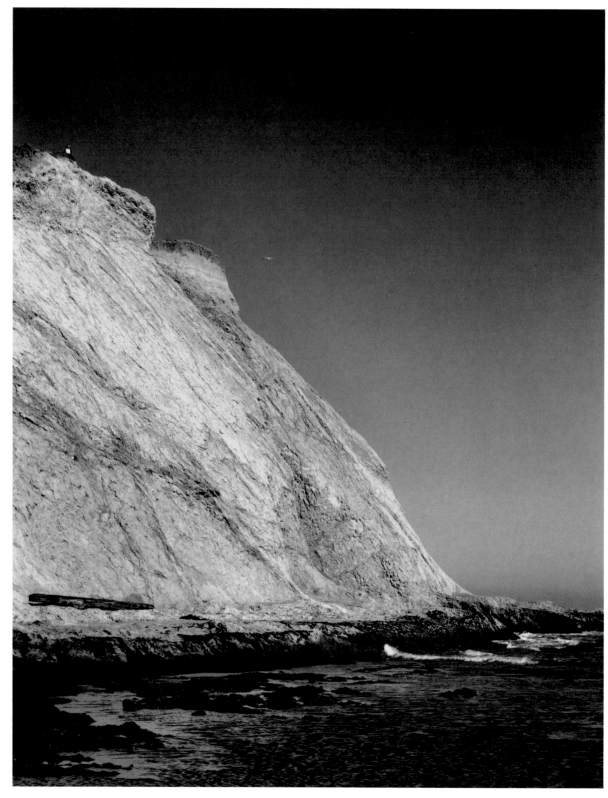

HEADLAND, SUR COAST, 1984

Walk on gaunt shores and avoid the people; rock and wave are good
 prophets;
Wise are the wings of the gull, pleasant her song.

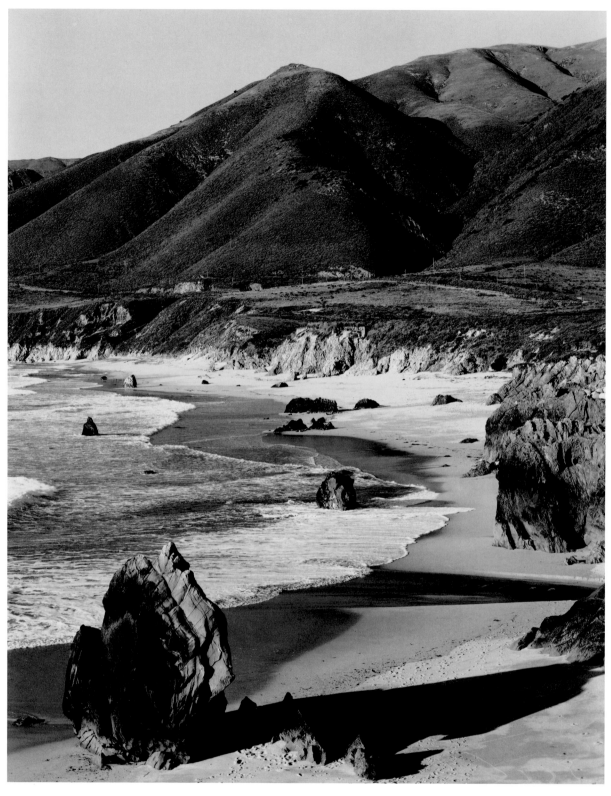

GARRAPATA BEACH, MARCH 1964

The coast hills at Sovranes Creek;
No trees, but dark scant pasture drawn thin
Over rock shaped like flame;
The old ocean at the land's foot, the vast
Gray extension beyond the long white violence;
A herd of cows and the bull
Far distant, hardly apparent up the dark slope;
And the gray air haunted with hawks:
This place is the noblest thing I have ever seen. No imaginable
Human presence here could do anything
But dilute the lonely self-watchful passion.

THE PLACE FOR
NO STORY
. .

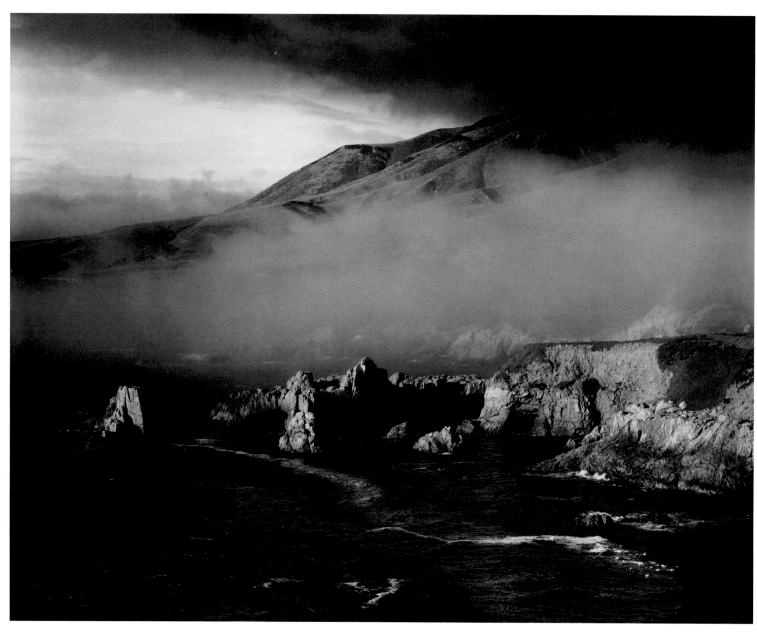

SOBERANES POINT, NORTH COVE, 1964

At night, toward dawn, all the lights of the shore have died,
And a wind moves. Moves in the dark
The sleeping power of the ocean, no more beastlike than manlike,
Not to be compared; itself and itself.
Its breath blown shoreward huddles the world with a fog; no stars
Dance in heaven; no ship's light glances.
I see the heavy granite bodies of the rocks of the headland,
That were ancient here before Egypt had pyramids,
Bulk on the gray of the sky, and beyond them the jets of young trees
I planted the year of the Versailles peace.
But here is the final unridiculous peace. Before the first man
Here were the stones, the ocean, the cypresses,
And the pallid region in the stone-rough dome of fog where the moon
Falls on the west. Here is reality.
The other is a spectral episode; after the inquisitive animal's
Amusements are quiet: the dark glory.

HOODED NIGHT
........................

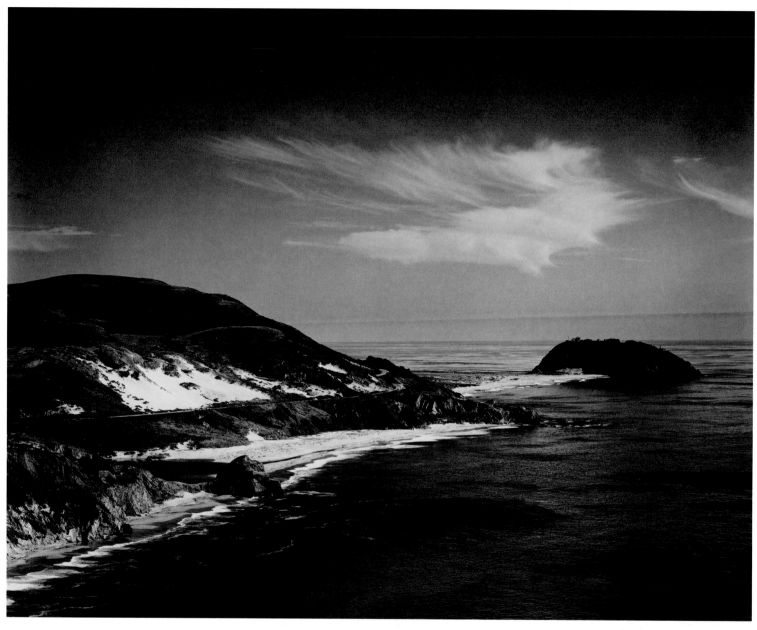

POINT SUR, 1969

The sea's tide
Rose too, white-sheeting the dark reefs at the rock-foot, in the dark south
the domed rock at Point Sur
Stood opposite the mainland wall of hills; clouds closed the sea-line;
landward far down the hill-slope a hawk
Hung like a wind-vane, motionless with beating wings in the stream of the
wind.

From THE WOMEN AT
POINT SUR
.........................

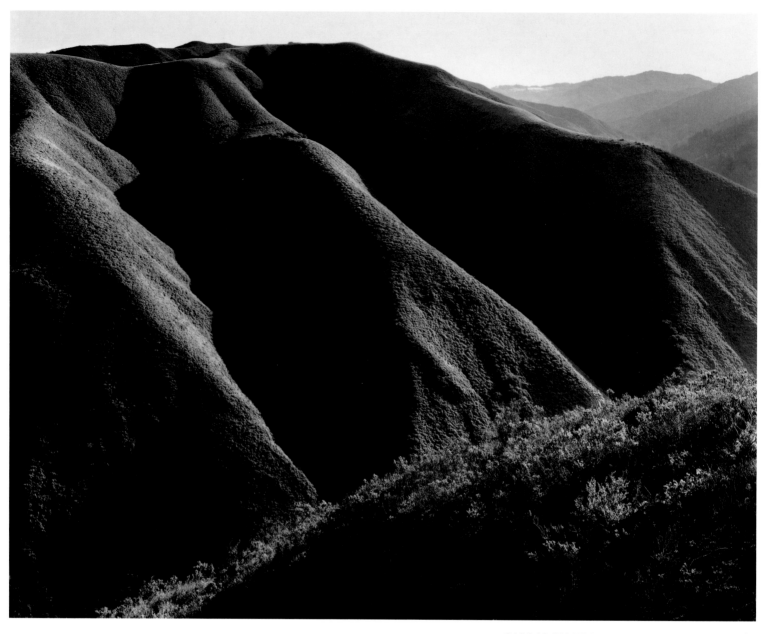

GARRAPATA FROM UPPER MESA RIDGE, 1964

The shored Pacific makes perpetual

music, and the stone mountains

Their music of silence

From MEDITATION

ON SAVIORS

........................ · · · ·

The world's as the world is; the nations rearm and prepare to change; the
 age of tyrants returns;
The greatest civilization that has ever existed builds itself higher towers on
 breaking foundations.
Recurrent episodes; they were determined when the ape's children first ran
 in packs, chipped flint to an edge.

I lie and hear dark rain beat the roof, and the blind wind.

 In the morning
 perhaps I shall find strength again
To value the immense beauty of this time of the world, the flowers of decay
 their pitiful loveliness, the fever-dream
Tapestries that back the drama and are called the future. This ebb of
 vitality feels the ignoble and cruel
Incidents, not the vast abstract order.

 I lie and hear dark rain beat the
 roof, and the night-blind wind.

In the Ventana country darkness and rain and the roar of waters fill the
 deep mountain-throats.
The creekside shelf of sand where we lay last August under a slip of stars
And firelight played on the leaning gorge-walls, is drowned and lost. The
 deer of the country huddle on a ridge
In a close herd under madrone-trees; they tremble when a rock-slide goes
 down, they open great darkness-
Drinking eyes and press closer.

 Cataracts of rock
Rain down the mountain from cliff to cliff and torment the stream-bed.
 The stream deals with them. The laurels are wounded,
Redwoods go down with their earth and lie thwart the gorge. I hear the
 torrent boulders battering each other,
I feel the flesh of the mountain move on its bones in the wet darkness.

 Is this
 more beautiful
Than man's disasters? These wounds will heal in their time; so will
 humanity's. This is more beautiful . . . at night . . .

White-maned, wide-throated, the heavy-shouldered children of the wind
 leap at the sea-cliff.
The invisible falcon
Brooded on water and bred them in wide waste places, in a bride-chamber
 wide to the stars' eyes
In the center of the ocean,
Where no prows pass nor island is lifted . . . the sea beyond Lobos is
 whitened with the falcon's
Passage, he is here now,
The sky is one cloud, his wing-feathers hiss in the white grass, my sapling
 cypresses writhing
In the fury of his passage
Dare not dream of their centuries of future endurance of tempest. (I have
 granite and cypress,
Both long-lasting,
Planted in the earth; but the granite sea-boulders are prey to no hawk's
 wing, they have taken worse pounding,
Like me they remember
Old wars and are quiet; for we think that the future is one piece with the
 past, we wonder why tree-tops
And people are so shaken.)

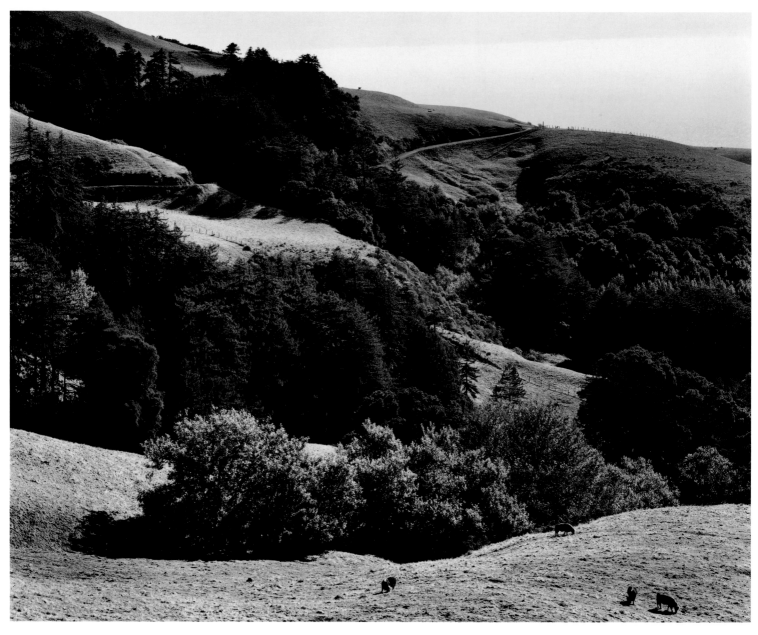

OLD COAST ROAD, EL SUR RANCH, 1968

 my love, my loved subject: *From* UNTITLED
Mountain and ocean, rock, water and beasts and trees .

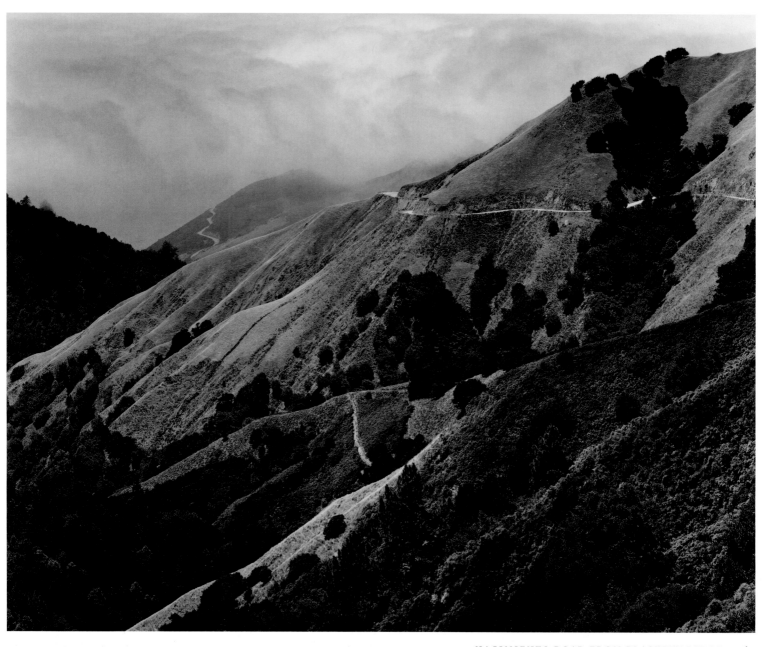

NACIMIENTO ROAD FROM PLASKETT RIDGE, 1969

The mountains, those were *real* persons, head beyond head, ridge, peak and
 dome
High dark on the gray sky; and the dark gullies and gorges and the rock
 hearts . . . slightly tortured . . .
The raw sore of this road cut in their feet:
The slow anger of the coast mountains: they'll get their own back
After some time. Things will be better then.
Rock-slides will choke the road, no one will open it.

From MARA
. .

 I say that if the mind centers on humanity
And is not dulled, but remains powerful enough to feel its own and the
 others, the mind will go mad.
It is needful to remember the stone and the ocean, without the hills over
 the house no endurance,
Without the domed hills and the night. Not for quietness, not peace;
They are moved in their times. Not for repose; they are more strained than
 the mind of a man; tortured and twisted
Layer under layer like tetanus, like the muscles of a mountain bear that has
 gorged the strychnine
With the meat bait: but under their dead agonies, under the nightmare
 pressure, the living mountain
Dreams exaltation; in the scoriac shell, granites and basalts, the reptile force
 in the continent of rock
Pushing against the pit of the ocean, unbearable strains and weights,
 inveterate resistances, dreams westward
The continent, skyward the mountain . . . The old fault
In the steep scarp under the waves
Melted at the deep edge, the teeth of the fracture
Gnashed together, snapping on each other; the powers of the earth drank
Their pang of unendurable release and the old resistances
Locked. The long coast was shaken like a leaf.

From THE WOMEN AT
POINT SUR
. .

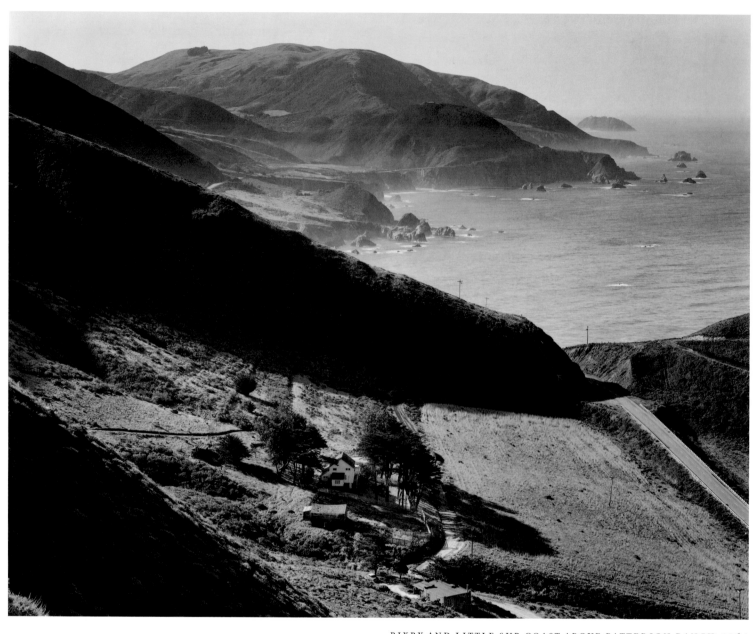

BIXBY AND LITTLE SUR COAST ABOVE PATTERSON RANCH, 1964

While George went to the house
For his revolver, Michal climbed up the hill
Weeping; but when he came with death in his hand
She'd not go away, but watched. At the one shot
The great dark bird leaped at the roof of the cage
In silence and struck the wood; it fell, then suddenly
Looked small and soft, muffled in its folded wings.

The nerves of men after they die dream dimly
And dwindle into their peace; they are not very passionate,
And what they had was mostly spent while they lived.
They are sieves for leaking desire; they have many pleasures
And conversations; their dreams too are like that.
The unsocial birds are a greater race;
Cold-eyed, and their blood burns. What leaped up to death,
The extension of one storm-dark wing filling its world,
Was more than the soft garment that fell. Something had flown away. Oh
 cage-hoarded desire,
Like the blade of a breaking wave reaped by the wind, or flame rising from
 fire, or cloud-coiled lightning
Suddenly unfurled in the cave of heaven: I that am stationed, and cold at
 heart, incapable of burning,
My blood like standing sea-water lapped in a stone pool, my desire to the
 rock, how can I speak of you?
Mine will go down to the deep rock.

This rose,
Possessing the air over its emptied prison,
The eager powers at its shoulders waving shadowless
Unwound the ever widened spirals of flight
As a star light, it spins the night-stabbing threads
From its own strength and substance: so the aquiline desire
Burned itself into meteor freedom and spired
Higher still, and saw the mountain-dividing
Canyon of its captivity (that was to Cawdor
Almost his world) like an old crack in a wall,

Violet-shadowed and gold-lighted; the little stain
Spilt on the floor of the crack was the strong forest;
The grain of sand was the Rock. A speck, an atomic
Center of power clouded in its own smoke
Ran and cried in the crack; it was Cawdor; the other
Points of humanity had neither weight nor shining
To prick the eyes of even an eagle's passion.

This burned and soared. The shining ocean below lay on the shore
Like the great shield of the moon come down, rolling bright rim to rim
 with the earth. Against it the multiform
And many-canyoned coast-range hills were gathered into one carven
 mountain, one modulated
Eagle's cry made stone, stopping the strength of the sea. The beaked and
 winged effluence
Felt the air foam under its throat and saw
The mountain sun-cup Tassajara, where fawns
Dance in the steam of the hot fountains at dawn,
Smoothed out, and the high strained ridges beyond Cachagua,
Where the rivers are born and the last condor is dead,
Flatten, and a hundred miles toward morning the Sierras
Dawn with their peaks of snow, and dwindle and smooth down
On the globed earth.

 It saw from the height and desert space of
 unbreathable air
Where meteors make green fire and die, the ocean dropping westward to
 the girdle of the pearls of dawn
And the hinder edge of the night sliding toward Asia; it saw far under
 eastward the April-delighted
Continent; and time relaxing about it now abstracted from being, it saw the
 eagles destroyed,
Mean generations of gulls and crows taking their world: turn for turn in the
 air, as on earth
The white faces drove out the brown. It saw the white decayed and the
 brown from Asia returning;

It saw men learn to outfly the hawk's brood and forget it again; it saw men
 cover the earth and again
Devour each other and hide in caverns, be scarce as wolves. It neither
 wondered nor cared, and it saw
Growth and decay alternate forever and the tides returning.

It saw, according to the sight of its kind, the archetype
Body of life a beaked carnivorous desire
Self-upheld on storm-broad wings: but the eyes
Were spouts of blood; the eyes were gashed out; dark blood
Ran from the ruinous eye-pits to the hook of the beak
And rained on the waste spaces of empty heaven.
Yet the great Life continued; yet the great Life
Was beautiful, and she drank her defeat, and devoured
Her famine for food.

 There the eagle's phantom perceived
Its prison and its wound were not its peculiar wretchedness,
All that lives was maimed and bleeding, caged or in blindness,
Lopped at the ends with death and conception, and shrewd
Cautery of pain on the stumps to stifle the blood, but not
Refrains for all that; life was more than its functions
And accidents, more important than its pains and pleasures,
A torch to burn in with pride, a necessary
Ecstasy in the run of the cold substance,
And scape-goat of the greater world. (But as for me,
I have heard the summer dust crying to be born
As much as ever flesh cried to be quiet.)
Pouring itself on fulfilment the eagle's passion
Left life behind and flew at the sun its father.
The great unreal talons took peace for prey
Exultantly, their death beyond death; stooped upward, and struck
Peace like a white fawn in a dell of fire.

. ...

My friend from Asia has powers and magic, he plucks a blue leaf from
 the young blue-gum
And gazing upon it, gathering and quieting
The God in his mind, creates an ocean more real than the ocean, the salt,
 the actual
Appalling presence, the power of the waters.
He believes that nothing is real except as we make it. I humbler have found
 in my blood
Bred west of Caucasus a harder mysticism.
Multitude stands in my mind but I think that the ocean in the bone vault is
 only
The bone vault's ocean: out there is the ocean's;
The water is the water, the cliff is the rock, come shocks and flashes of
 reality. The mind
Passes, the eye closes, the spirit is a passage;
The beauty of things was born before eyes and sufficient to itself; the
 heart-breaking beauty
Will remain when there is no heart to break for it.

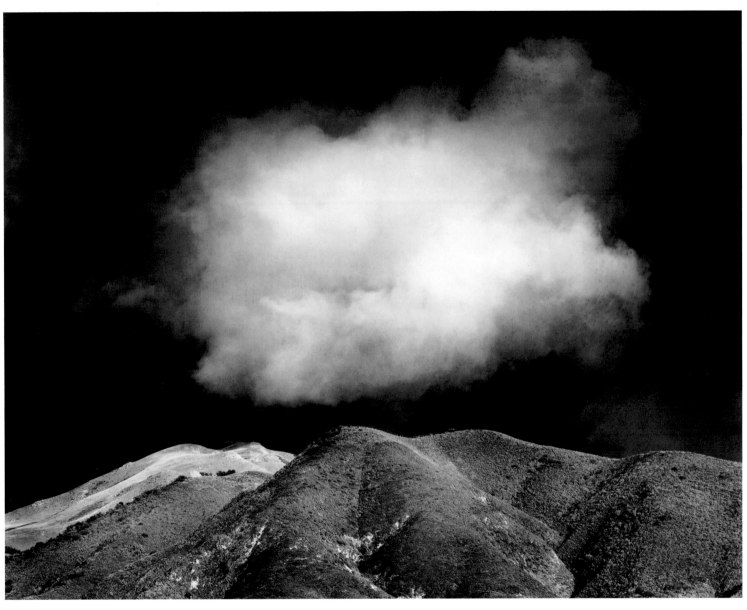

SPRING STORM, PORTUGUESE RIDGE, 1971

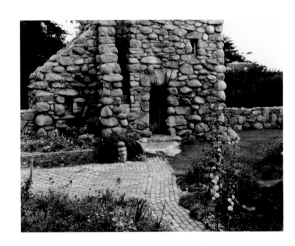

THE OLD
STONE-MASON

Against the outcrop boulders of a raised beach
We built our house when I and my love were young.
Here long ago the surf thundered, now fifty feet lower;
And there's a kind of shell-mound, I used to see ghosts of Indians
Squatting beside the stones in their firelight,
The rock-cheeks have red fire-stains. But the place was maiden, no previous
Building, no neighbors, nothing but the elements,
Rock, wind and sea; in moon-struck nights the mountain coyotes
Howled in our dooryard; or doe and fawn
Stared in the lamp-lit window. We raised two boys here; all that we saw or
 heard was beautiful
And hardly human.

 Oh heavy change.
The world deteriorates like a rotting apple, worms and a skin.
They have built streets around us, new houses
Line them and cars obsess them . . . and my dearest has died.

The ocean at least is not changed at all,
Cold, grim and faithful; and I still keep a hard edge of forest
Haunted by long gray squirrels and hoarse herons:
And hark the quail, running on the low roof's worn shingles
Their little feet patter like rain-drops.

August and laurelled have been content to speak for an age, and the ages
 that follow
Respect them for that pious fidelity;
But you have disfeatured time for timelessness.
They had heroes for companions, beautiful youths to dream of,
 rose-marble-fingered
Women shed light down the great lines;
But you have invoked the slime in the skull,
The lymph in the vessels. They have shown men Gods like racial dreams,
 the woman's desire,
The man's fear, the hawk-faced prophet's; but nothing
Human seems happy at the feet of yours.
Therefore though not forgotten not loved, in gray old years in the evening
 leaning
Over the gray stones of the tower-top,
You shall be called heartless and blind;
And watch new time answer old thought, not a face strange nor a pain
 astonishing:
But you living be laired in the rock
That sheds pleasure and pain like hail-stones.

SOLILOQUY
. .

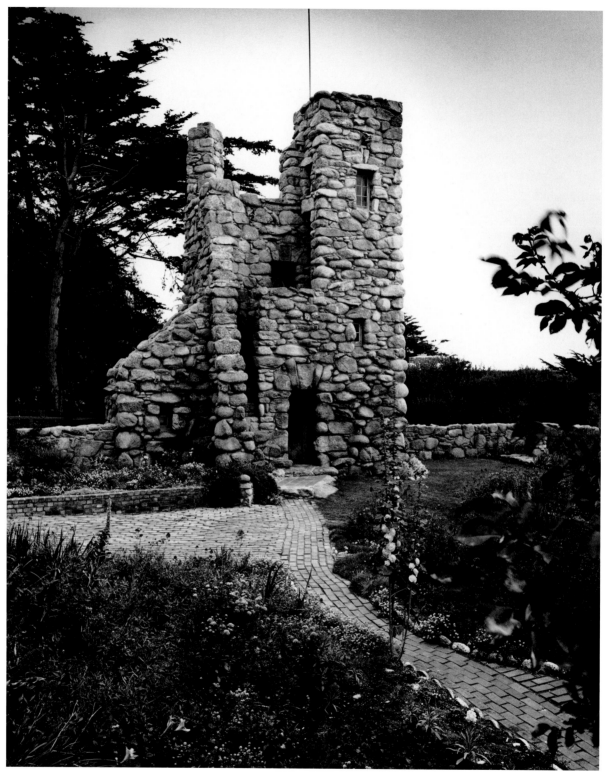

HAWK TOWER, 1968

On the small marble-paved platform
On the turret on the head of the tower
Watching the night deepen.
I feel the rock-edge of the continent
Reel eastward with me below the broad stars,
I lean on the broad worn stones of the parapet-top
And the stones and my hands that touch them reel eastward.
The inland mountains go down and new lights
Glow over the sinking east rim of the earth.
The dark ocean comes up,
And reddens the western stars with its fog-breath
And hides them with its mounded darkness.

The earth was the world and man was its measure, but our minds have
 looked
Through the little mock-dome of heaven the telescope-slotted observatory
 eye-ball, there space and multitude came in
And the earth is a particle of dust by a sand-grain sun, lost in a nameless
 cove of the shores of a continent.
Galaxy on galaxy, innumerable swirls of innumerable stars, endured as it
 were forever and humanity
Came into being, its two or three million years are a moment, in a moment
 it will certainly cease out from being
And galaxy on galaxy endure after that as it were forever . . . But man is
 conscious,
He brings the world to focus in a feeling brain,
In a net of nerves catches the splendor of things,
Breaks the somnambulism of nature . . . His distinction perhaps,
Hardly his advantage. To slaver for contemptible pleasures
And scream with pain, are hardly an advantage.
Consciousness? The learned astronomer
Analyzing the light of most remote star-swirls
Has found them—or a trick of distance deludes his prism—
All at incredible speeds fleeing outward from ours.
I thought, no doubt they are fleeing the contagion
Of consciousness that infects this corner of space.

From MARGRAVE
· ·

For often I have heard the hard rocks I handled
Groan, because lichen and time and water dissolve them,
And they have to travel down the strange falling scale
Of soil and plants and the flesh of beasts to become
The bodies of men; they murmur at their fate
In the hollows of windless nights, they'd rather be anything
Than human flesh played on by pain and joy,
They pray for annihilation sooner, but annihilation's
Not in the book yet.

Stones that rolled in the sea for a thousand years
Have climbed the cliff and stand stiff-ranked in the house-walls;
Hurricane may spit his lungs out they'll not be moved.
They have become conservative; they remember the endless
Treacheries of ever-sliding water and slimy ambushes
Along the shore; they'll never again give themselves
To the tides and the dreams, the popular drift,
The whirlpool progress, but stand steady on their hill—
At bay?—Yes; but unbroken.

 I have much in common with these old
 rockheads.
Old comrades, I too have escaped and stand.
I have shared in my time the human illusions, the muddy foolishness
And craving passions, but something thirty years ago pulled me
Out of the tide-wash; I must not even pretend
To be one of the people. I must stand here
Alone with open eyes in the clear air growing old,
Watching with interest and only a little nausea
The cheating shepherds, this time of the demagogues and the docile
 people, the shifts of power,
And pitiless general wars that prepare the fall;
But also the enormous unhuman beauty of things; rock, sea and stars,
 fool-proof and permanent,
The birds like yachts in the air, or beating like hearts
Along the water; the flares of sunset, the peaks of Point Lobos;
And hear at night the huge waves, my drunken quarrymen
Climbing the cliff, hewing out more stones for me
To make my house. The old granite stones, those are my people;
Hard heads and stiff wits but faithful, not fools, not chatterers;
And the place where they stand to-day they will stand also to-morrow.

Gray steel, cloud-shadow-stained,
The ocean takes the last lights of evening.
Loud is the voice and the foam lead-color,
And flood-tide devours the sands.

Here stand, like an old stone,
And watch the lights fade and hear the sea's voice.
Hate and despair take Europe and Asia,
And the sea-wind blows cold.

Night comes: night will claim all.
The world is not changed, only more naked:
The strong struggle for power, and the weak
Warm their poor hearts with hate.

Night comes: come into the house,
Try around the dial for a late news-cast.
These others are America's voices: naive and
Powerful; spurious; doom-touched.

How soon? Four years or forty?
Why should an old stone pick at the future?
Stand on your shore, old stone, be still while the
Sea-wind salts your head white.

Intense and terrible beauty, how has our race with the frail naked nerves,
So little a craft swum down from its far launching?
Why now, only because the northwest blows and the headed grass billows,
Great seas jagging the west and on the granite
Blanching, the vessel is brimmed, this dancing play of the world is too
 much passion.
A gale in April so overfilling the spirit,
Though his ribs were thick as the earth's, arches of mountain, how shall one
 dare to live,
Though his blood were like the earth's rivers and his flesh iron,
How shall one dare to live? One is born strong, how do the weak endure it?
The strong lean upon death as on a rock,
After eighty years there is shelter and the naked nerves shall be covered
 with deep quietness,
O beauty of things go on, go on, O torture
Of intense joy I have lasted out my time, I have thanked God and finished,
Roots of millennial trees fold me in the darkness,
Northwest wind shake their tops, not to the root, not to the root, I have
 passed
From beauty to the other beauty, peace, the night splendor.

GALE IN APRIL
......................... . .

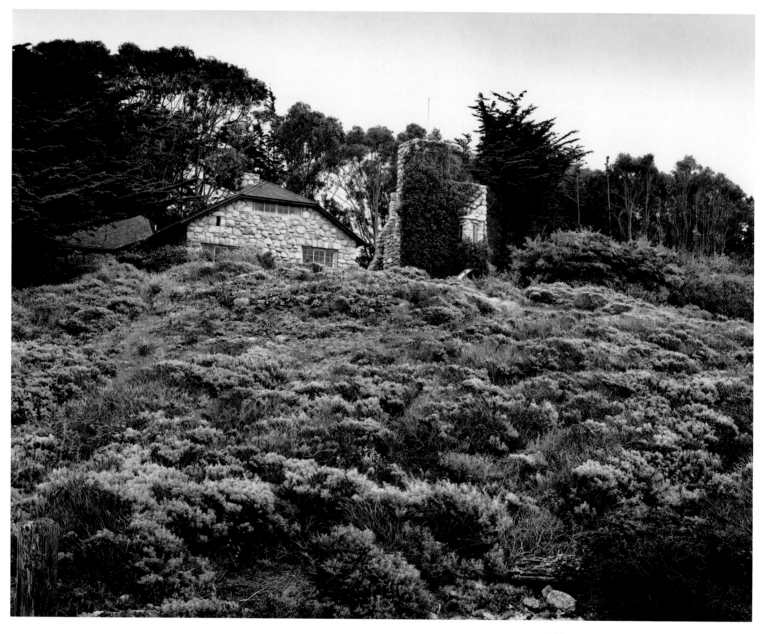

TOR HOUSE AND HAWK TOWER, 1964

156

Happy people die whole, they are all dissolved in a moment, they have
 had what they wanted,
No hard gifts; the unhappy

Linger a space, but pain is a thing that is glad to be forgotten; but one who
 has given
His heart to a cause or a country,
His ghost may spaniel it a while, disconsolate to watch it. I was wondering
 how long the spirit
That sheds this verse will remain
When the nostrils are nipped, when the brain rots in its vault or bubbles in
 the violence of fire
To be ash in metal. I was thinking
Some stalks of the wood whose roots I married to the earth of this place
 will stand five centuries;
I held the roots in my hand,
The stems of the trees between two fingers: how many remote generations
 of women
Will drink joy from men's loins,
And dragged from between the thighs of what mothers will giggle at my
 ghost when it curses the axemen,
Gray impotent voice on the sea-wind,
When the last trunk falls? The women's abundance will have built roofs
 over all this foreland;
Will have buried the rock foundations
I laid here: the women's exuberance will canker and fail in its time and like
 clouds the houses
Unframe, the granite of the prime
Stand from the heaps: come storm and wash clean: the plaster is all run to
 the sea and the steel
All rusted; the foreland resumes
The form we loved when we saw it. Though one at the end of the age and
 far off from this place
Should meet my presence in a poem,
The ghost would not care but be here, long sunset shadow in the seams of
 the granite, and forgotten
The flesh, a spirit for the stone.

Poems

Volume and page numbers following the titles refer to the location of poems in *The Collected Poetry of Robinson Jeffers*, Volumes I, II, and III, edited by Tim Hunt (Stanford: Stanford University Press, 1988, 1989, and 1991).

Photographs

Occasionally, over the years, Morley Baer altered the titles of his photographs. To assure accurate identification, the inventory number he assigned to each negative is included here.

Poetry on pages 30, 35, 39, 46, 47, 55, 73, 97, 111, 114, 115, 125, 127, 149, and 153 from *The Selected Poetry of Robinson Jeffers* by Robinson Jeffers.

Copyright © 1924, 1925, 1928, 1932 by Robinson Jeffers.

Copyright renewed 1952, 1953, 1956, 1960 by Robinson Jeffers.

Copyright © 1932 and renewed by Duncan Jeffers and Garth Jeffers.

Copyright © 1941, 1948, 1951, 1954 by Robinson Jeffers.

Copyright © 1963 by Stueben Glass.

Reprinted by permission of Random House, Inc.

All other poetry © Jeffers Literary Properties. Reprinted by permission.

Library of Congress Cataloging-in-Publication Data
Jeffers, Robinson, 1887–1962.
 Stones of the sur / poetry by Robinson Jeffers ;
 photographs by Morley Baer ; selected and
 introduced by James Karman.
 p. cm.
 Includes bibliographical references and index.
 ISBN 0-8047-3942-0 (alk. paper)
 1. Big Sur (Calif.)—Poetry. 2. Big Sur (Calif.)—
 Pictorial works. I. Baer, Morley. II. Karman, James.
 III. Title.
 PS3519.E27 S76 2001
 811'.52—dc21 2001020021

Original Printing 2001
Last figure below indicates year of this printing:
10 09 08 07 06 05 04 03 02 01

Designed by Eleanor Mennick
Typeset by James B. Brommer in 10/15 Galliard
Printed in the Fultone® process by Gardner Lithograph